COMPLETE

USER'S GUIDE

MODERN CLASSICS

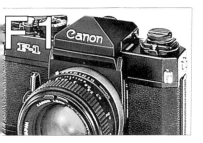

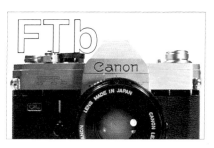

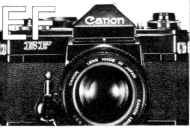

ORIGINAL

HOVE FOTO BOOKS

Harald Francke

Canon Modern Classics

Reprinted July 1993
Reprinted December 1992
First Edition January 1991
Published by Hove Foto Books
Jersey Photographic Museum, Hotel de France
St. Saviour's Road, Jersey, Channel Islands
Tel No. (0534)) 73102 Fax No. (0534) 35354
Printed by The Guernsey Press Co. Ltd,
Commercial Printing Division, Guernsey, Channel Islands

British Library Cataloguing in Publication Data
Francke, Harald
Users guide to Canon modern classics.
1. Cameras
I. title II (Canon Kameras von Gestern fur
Anwender von Heute). English 771.32

ISBN 0-906447-74-7

Worldwide Distribution

Newpro (UK) Ltd
Old Sawmills Road
Faringdon, Oxon
SN7 7DS England

Canon Modern Classics

Harald Francke

HOVE FOTO BOOKS

CAMERA MANUALS FROM HOVE

International *U.S.A.*

Also available worldwide, complete users guides to classic SLR's from the 70's and 80's.

Canon Modern Classics – includes F-1,FIB,EF,AE-1,AE-1P
Nikon Modern Classics – includes F2,EL,FM,FE2,F12,FA
Olympus Modern Classics – includes OM-1, OM-2,OM-10,OM-3/OM-4,OM-2sp,OM-40
Pentax Modern Classics – includes ES11,Spotmatic F,K2,KX/KM,ME/MX,ME Super
Nikon F2 Modern Classics – includes F2,F2 Photomic, F2s Photomic, F2SB,F2A,F2AS

Hove Pro Guides

Canon EOS System
Hasselblad System
Mamiya System
Nikon System

⌷ HOVE FOTO BOOKS

Contents

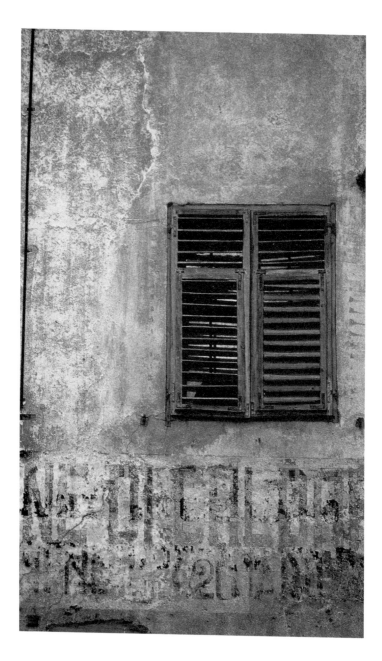

Old or Old Hat?

New cameras are coming on the market all the time and Canon plays an important part in the flood of new sophisticated products. The introduction of the autofocus Canon EOS 650 and EOS 620 cameras in the spring of 1987 was followed by the Canon EOS 850, EOS 750, EOS 700, EOS 600, EOS 10 and the top model EOS 1 as well as the special edition EOS RT. That represents nine single lens reflex cameras in under four years and Photokina '90 featured the EOS 1000.

What is the point then of a book about single lens reflex cameras, which came on the market nearly ten years ago? And more important for you, the reader, what is the point of reading such a book?

Well, I am convinced it makes sense.

It is certainly very convenient to work with these new cameras. The advantages of split second autofocus, five frames per second film winding motor, camera controlled flash and a single lithium battery power source cannot be denied.

When I show a few slides from my rather disorganised archive, however, hardly anyone can tell the difference between those taken with a modern EOS-1 and my fifteen-year old Canon EF.

Left: An observant eye can often find an interesting subject in rural areas - like the faded writing on this old wall. The type of camera used - ultra-modern autofocus SLR or an older type - does not matter at all.

There are two reasons for this. For one, it was I who took these pictures, my eyes, my perception of the subject, my sense of composition. I decide whether they are a success or a failure. The camera is a useful tool to achieve these results but it has no influence at all on the transformation of my ideas into a picture.

Secondly, even the most modern cameras cannot change the basic principles of photography. The lens must be focused to achieve a sharp image. The lighting must be determined and if required the exposure must be adjusted for the main subject. The aperture governs the amount of light reaching the film and determines the extent of the depth of field. The shutter controls the duration of the exposure which in turn determines whether movement is blurred or frozen. Flash exposure always depends on the aperture, which when chosen correctly allows enough natural light to reach the film during synchronization to illuminate all parts of the subject correctly. All this modern cameras manage automatically. But when exploited to the full, 10- or 20-year old cameras achieve the same results. The path is perhaps a little more complicated but it is great fun to work out exactly why what is done when; and if you are unsure of the result of a certain action beforehand the picture will tell you at the end and the experience gained can be incorporated in future shots.

Good or bad pictures can be taken with old or new cameras alike. Which one to go for is also a question of money. New cameras with all mod cons are usually quite expensive; and when resources are limited all the sophisticated gadgetry in the world cannot stretch them further.

Modern low-priced, not to say cheap, cameras on the other hand are nothing but fully automatic cameras leaving the photographer very little scope for individuality, and being able to choose lies at the root of photography as a hobby.

Old or second-hand cameras provide an excellent opportunity to enter the field of photography with a small budget. Not only are there low cost cameras available but all kinds of accessories from lenses to tripods can be acquired for the price of a basic modern camera. If the range of accessories is no

longer available for a particular camera, very often new accessories can be used with older cameras.

Because it is possible to achieve excellent results with older cameras and because these cameras offer an affordable introduction to one of the nicest hobbies I am convinced that a book like this makes sense and I hope you find it interesting.

Harald Francke

Collecting suitable subjects is an interesting part of photography. An old gate is just one example. Very little equipment is necessary for good results - just a 35mm, a normal and a 85mm lens.

The Tradition of Canon

The rise of the company started in the 30's under the name of "Seiki Kogaku Kenyujo" and was one of the many optical manufacturers trying to emulate the great cameras of German design. The resulting viewfinder camera named "Kwanon" after a Japanese goddess was introduced two years later as "Hansa Canon" and equipped with a Nikkor lens. The Nikon company at that time had also not yet reached the world status it enjoys today.

The rangefinder cameras of the Leica and Contax school, or of a mixture of both of these, were improved by Canon in the following years, new cameras were introduced and the range of accessories was extended.

After World War II rangefinder and viewfinder cameras again left the Canon production lines.

A special position was held by the Canon Dial 35 which was different in three ways; it was a half-frame camera for negatives or positives of 18x24mm, its body was arranged vertically and it featured a clockwork mechanism to wind the film.

A highlight in the development of rangefinder cameras in 1960 was the Canon 7 with a lens of an incredible f/0.95 aperture. In the improved version of Canon 7S this camera later marked Canon's departure from system rangefinder cameras with interchangeable lenses. From then on the market was dominated by either single lens reflex or compact viewfinder cameras. The latter often still featured a coupled rangefinder but since 1979 most cameras of this class are focused automatically. The Canon AF 35 M is a compact camera with an active infrared AF system, built-in flash and motor representing a type of camera still dominating the market today.

As the Canon 7S disappeared from the market the company had been producing single lens reflex cameras for some time. The first SLR under the Canon name was the Canonflex R featuring a focal plane shutter with exposure times from 1 to $^1/1000$ sec, a removable pentaprism viewfinder, and X and FP

synchronization. Exposure was still metered by a separate clip-on meter. A peculiarity of this model was the quick wind lever on the bottom of the camera and the film rewind button on the top plate.

Such an unusual arrangement for the winding elements was also found on the Canonflex R2000 which as early as 1959 offered a top shutter speed of $^1/2000$ sec.

The Canonflex RM introduced three years later was already equipped with a built-in exposure meter albeit a selenium meter mounted above the lens.

The exposure meter of the Canon FX used a cadmium suphide cell, but it was not housed within the camera body, but was positioned on the left of the top plate. In all other respects the Canon FX corresponded to the image of a modern SLR camera with quick wind lever and film rewind button at the top, a large shutter speed dial, self-timer lever at the front to the right of the lens and with a flash shoe which featured no "hot" contact as yet. The FP model introduced a little later was again equipped with a clip-on exposure meter and was therefore somewhat cheaper.

Hand in hand with the change to the F models went the change from the R lens connection to the FL bayonet fitting.

The next SLR, the Canon Pellix of 1965, featured a fixed mirror and as there was no mirror movement the camera was consequently very quiet and vibration-free. This feature recently caused a stir again in the Canon EOS RT. More important than this, however, was the positioning of the light meter in the camera body. A year later the Pellix was equipped with a quick-loading system and was called the Pellix QL.

The Canon FT QL also featured a quick-loading system.

Two years later, in the 1960s, the introduction of new cameras slowed down. In 1968 the Canon TL QL completed the range whose shutter speeds only reached $^1/500$ sec.

Just before the end of the decade Canon introduced the EX EE in 1969, a camera that unlike the other Canon cameras featured convertible lenses with the rear lens component fixed to the camera body. There was a choice of three lens front groups - a 35mm, a 50mm and a 125mm.

In 1971 Canon introduced a camera, the Canon F-1, which proved for many years that the company could build a professional camera of the highest standard. The lens system was changed and the FL connection replaced with a FD bayonet which is still used in principle today. In the same year the Canon FTb QL appeared, an improved version of the FT. The years until the end of 1973 were spent on improvements and modifications. In 1972 the EX Auto came on the market as an advancement on the EX EE, and to coincide with the Olympic Games of the same year the Canon F-1 was introduced as a quick-shot camera. This special version offered up to nine frames per second. In October 1973 the FTb-N appeared. It was not until November of that year that Canon's first new SLR came on the market - the Canon EF. At yearly intervals, two further modified cameras were introduced, first the TLb followed by the TX.

By the year 1976 the world of SLR cameras was changed dramatically. Canon introduced its Canon AE-1, a camera dedicated to the use of electronics, very well equipped and costing a great deal less than the competition hoped for.

The Canon AE-1 took over from the F series leaving only the F-1 as a professional camera to be revised in 1976.

A sister model to the AE-1 appeared in 1977 in the form of the Canon AT-1 which dispensed with automatic exposure, appealing to those photographers preferring to set shutter speed and aperture manually.

The Canon A-1 appearing in the winter of 1977/78 again was a trend-setter because of its multiple automatic features, although Minolta was a step ahead with its XD-7. The Canon AV-1 of 1979 appealed to all fans of shutter priority which up until now had only been available as a version of exposure control in the Canon A-1.

The AE-1 Program in the following year also offered some form of exposure control previously reserved for the A-1 - automatic programming.

The Canon F-1 was still available although rather dated by this time. Canon therefore introduced a new professional camera under the traditional banner of F-1 but with a "new"

added to its name - Canon F-1N. The construction of this camera was modular. The body and standard viewfinder allowed exposure metering with tracking selection. People found out very quickly that the standard equipment of the camera allowed aperture priority selection albeit without shutter speed indication which was only possible with the automatic viewfinder FN. The motor or winder could convert the F-1N to automatic aperture control. The interchangeable focusing screens used to select three versions of exposure metering were part of the modular system.

In 1982 a camera came on the market which turned out to be the last of Canon's A series - the AL-1 based on the AV-1 but equipped with a forerunner of an autofocus system. Three LCD indicators advised on the direction the focusing rings needed to be turned (by hand) and whether the subject was in focus. Like other cameras of this type the Canon AL-1 could not gain ground but it proved through the AF-Zoom 35-70mm,f/4.0, introduced at Photokina'80, that AF technology was moving to a viable position for SLR cameras.

Then in 1983 Canon presented a rather insignificant camera which was designed to be controlled entirely by automatic programming and which hinted at a completely new concept. This camera was the Canon T50 and was the first SLR to feature a built-in film winding motor.

The Canon T70, a year later, followed the same design principle but featured an LCD panel on the top plate for the first time. It also offered integral metering, metered value storage and, of course, a built-in motor.

In the same way that the old Canon F-1 was developed parallel to the A-series the F-1N continued to feature in the program parallel to the T cameras. The next camera in the T-series was the T80, an autofocus camera perhaps not quite on a par with the new Minolta 7000, but nevertheless featuring a symbol program and autofocus motor in the lenses and therefore pointing towards things to come (although the EOS 10 was not conceived yet!).

Everyone was expecting a rival to the Minolta 7000 and 9000 from the house of Canon, and sure enough a camera was pre-

Partial metering - only the important things are metered

Exposure metering in the FTb occurs in a small rectangular measuring zone indicated in the viewfinder by a fine-line frame slightly darker in shading than the rest. As about 22% of the incoming light is diverted for exposure metering the measuring zone appears around half an aperture stop darker than the remaining viewfinder image.

The measuring zone includes 12% of the viewfinder area which is a good compromise between integral metering over the entire picture and spot metering where only a small section of the subject is included for exposure metering purposes.

For a snapshot the FTb and its method of measuring can capture a subject quickly within the measuring field. The 12% measuring zone also allows the exposure to be adjusted accurately for a particular subject area which is of great importance for the overall effect.

The viewfinder image of a second generation FTb. Below left is the shutter speed, on the right is the exposure information display.

If no particular subject area is important it is recommended to adjust the exposure for bright subject areas to achieve good strong colours in slide films. This is more important with older films like Ektachrome 100 than with the newer types of emulsion such as Ektachrome 100 HC which offer better colour saturation. When a negative film is used in the FTb it is better to adjust the exposure for the shaded areas to achieve a well balanced negative that will enlarge well, no matter whether a black-and-white film like Kodak T-Max or a colour film like Kodacolor Gold is used.

Button cell - Not imperative but better

Everything said about exposure up until now naturally only applies to a FTb with a 1.3V mercury button cell inserted and whose main switch - surrounding the film rewind lever - is turned to ON.

Unlike the selenium cell the CdS cell does not generate power from the incoming light. CdS alters its electrical resistance depending on the brightness and this can only be utilized for measuring when there is power. But there is no need to despair if the mercury cell expires. Apart from the light meter all other functions remain available in the FTb, even without power.

With a metering area of 12% just the flowers and leaves make up the main subject. By manually setting the shutter speed and aperture a different portion of the subject could also have been chosen, once exposure had been set, without the picture appearing lighter of darker.

The gloomy day was emphasized by closing the aperture after exposure metering, thereby giving less exposure.

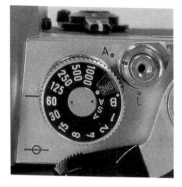

The film speed scale is displayed through a window which is part of the shutter speed selector. The upper limit is ISO 1600/33°.

Film speed - still sufficient

Another prerequisite for correct exposure is the setting of the film speed which must be entered manually by means of the shutter speed wheel. This is achieved by lifting the wheel slightly against the resistance of a spring. The range of film speeds is limited to ISO 25/15° at one end and to ISO 800/30° at the other.

While the lowest setting is sufficient for normal shooting - perhaps with a Ektar 25 or Kodachrome 25 - the upper limit appears to be set rather low for today's expectations. When a high-speed slide film such as Ektachrome P800/1600 should be utilized to the fullest there could be problems. But on second glance the ISO 800/30° films are still useful even today. The fact that there are very high-speed films available does not mean they have to be used all the time. On the contrary they are used quite rarely and many a dedicated photographer has never used them in his life. In most cases high speed films like Ektachrome 400 or T-Max 400 are quite sufficient.

DX-coding was still unheard of when the FTb was introduced. Those among us who use other cameras beside the FTb would do well to check the film speed setting on the FTb every so often. A film reminder such as offered by the Hama catalogue should be fixed to the back of the FTb in any case. If after loading the film the flap of the carton is attached to the clip you can quickly check whether the ISO number set is correct for the new film or left over from the previous one.

The shutter speed range is from 1 to 1/1000 sec plus B.

Manual exposure control - everything is possible

Exposure metering determines exposure control, which in the case of the FTb has to be done manually by setting both the aperture and the shutter speed. You may wish to give priority to a small aperture in order to increase depth of field, or you may want to freeze movement by selecting a certain shutter speed, for example. Apertures are set using the aperture ring on the lens. The aperture range available on the camera extends from 1 to $^1/1000$ sec - less than on many modern cameras, but quite adequate.

If you have selected a shutter speed - which I prefer to do - turn the aperture ring until the match needle coincides with the metering needle. Both needles are located in the viewfinder, but may be difficult to see if a dark portion of the image is behind them.

If on the other hand you wish to preselect an aperture, you will have to turn the shutter speed ring at the same time in order to get the two needles to coincide and this can be awkward. Hold the camera in the left hand so that you can turn the aperture ring with the thumb or middle finger of the right hand. In that way you can keep the index finger of the right hand on the shutter release.

Viewfinder information - nothing to write home about

No FTb indicates the selected aperture in the viewfinder. But whereas only the user of the first FTb version remains ignorant of the shutter speed while holding the camera to the eye, the revised version of 1973 shows the shutter speed - small and insignificant - in the lower left-hand corner of the viewfinder image. On the right side are the measuring needle, the indicator and the index for working aperture metering with two dark areas above and below. When the needle points to one of these fields there is danger of under- or overexposure and the shutter speed must be adjusted accordingly.

When the needle points to the lower field and there is also a red indicator visible in the viewfinder the light is too weak for the correct aperture/shutter speed combination to be set for the particular film loaded. There is no reason to forego taking a picture - just change to a higher film speed and add a booster or a flash.

In the centre of the viewfinder screen a microprism ring is provided as a focusing aid. With slow lenses, aperture f/5.6 or smaller, it is too dark to be useful, but with all other lenses a flickering of the microprism indicates when the image is not in focus. According to Canon the viewfinder image shows 94% of the actual exposed film format and therefore conforms to the film format used when the slide is inserted in a Kodak slide mount.

Main switch - don't forget it

As mentioned earlier the Canon FTb features a main switch which activates the exposure meter. It is therefore not necessary - unlike with many newer camera - to press the shutter release for exposure metering. The shutter release is only required to actually expose the frame.

To prevent inadvertent exposure the shutter release of the FTb can be locked by means of a small switch, useful when

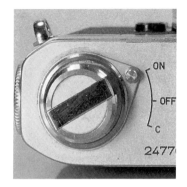

The main switch of the FTb activates the exposure meter only. The shutter can be operated without batteries and with the main switch in the OFF position.

trying out an FTb for the first time. Used to activate the exposure meter in more modern cameras like the Canon AE-1 or the T70, lightly pressing the shutter release on an FTb will result in a picture. Obviously a locked shutter could also frustrate your efforts when taking snapshots, but when choosing more static subjects like landscapes, architecture or flowers there is enough time to unlock it.

Loading the film - simple, quick and safe

Compared to modern autofocus SLR cameras using the Canon FTb is a calm, rather sedate affair which is a good thing as there is more time to study the subject for focusing and exposure purposes. But there is one area where the old FTb is at least equal to - if not better - than more modern cameras and that is the quick-load mechanism for the film. Simply open the camera back by pulling up the film rewind lever, insert the film cassette and pull the film leader to the marker. Close the camera back by which a plate with two rollers belonging to the quick load mechanism is automatically placed over the take-up spool and sprockets. Just ensure that the perforations of the film engage properly in the teeth of the transport mechanism.

Loading the film is very easy. Pull up the film rewind knob to open the rear cover. A hinged cover plate inside with two rollers will also open. Insert the film cassette and pull the film leader over to the marker. Close the plate and back cover and operate the film advance lever.

Once the back cover is closed advance the film wind lever and release the shutter twice to wind the film to the first frame. Check the film rewind button for movement indicating that the film is properly engaged.

Last but not least

The stop-down lever...

...of the FTb has two functions. One is the metering of the exposure in the working aperture setting and the other is when the depth of field is used as a creative element of the picture, in which case decide on an aperture, push the stop-down lever to the left, e.g. towards the lens, and you can observe in the viewfinder how the focal plane becomes a focal zone when the aperture is fully opened. By opening and closing the aperture this focal zone can be decreased or increased until all the required subject planes are covered. In landscape or macro photography it is a good idea to lock the lever by simply operating the switch underneath it.

The self-timer...

...by pushing the stop-down lever the other way, e.g. away from the lens, the self-timer sequence starts and after the shutter is released the stop-down lever returns to its normal position. Exposure occurs about ten seconds after the shutter release button has been pressed.

The self-timer is not only useful to include oneself in the picture but also when a tripod is used for exposures with slow shutter speeds.

Accessories - Booster, CAT etc.

The exposure meter of the Canon FTb has a range of EV 3 to EV 18 provided an ISO 100/21° film has been loaded and a lens with a maximum aperture of f/1.4 is used. If an aperture of f/1.4 and $^1/4$ sec are insufficient because of low light the exposure meter cannot determine the correct exposure. This also

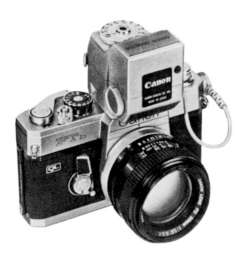

applies in very bright light when $^1/1000$ sec and f/16 are insufficient.

The exposure meter booster increases the metering range downwards to an exposure value of -3.5. As the aperture can only be opened to f/1.4 and the slowest speed is 1 sec this means in effect that even a very high speed film of ISO 1600/33° can be exposed correctly. Naturally exposure can also be metered with aperture f/1.4 and 16 sec for a ASA 100 film and the slow speed can be controlled via the B setting.

The exposure booster slots into the accessory shoe and is connected to the camera by a cable. The camera's battery must be removed as the booster is powered by two batteries of the same type.

There are three contact points in the hot shoe of the FTb. The largest serves to operate all flash units with hot shoe contact. The other two contacts are used for the CAT system with suitable flash units and lenses.

Exposure is also metered through the lens (TTL) when the booster is used but the lens must be stopped down. The recommended procedure is to locate the subject in the viewfinder and adjust the head of the essential tripod exactly, then stop down and meter the exposure.

Another method of photographing in the dark is by using flash. The FTb features a "hot shoe" activating any flash unit with hot contact through the camera. Older computer flash units such as the Vivitar 283 can be used although not with the CAT (Canon Automatic Tuning) system option.

CAT is a speciality by which it is possible to adjust the flash aperture semi-automatically to the shooting distance. It is limited to the Speedlite 133D and the FD 50mm,f/1.4; FD 50mm,f/1.8; FD 35mm,f/2.0 and FD 35mm,f/3.5 lenses.

Canon F-1 - The Professional Camera for a Decade

"When the F-1 appeared a few years ago it received great praise. Since then it has gained the reputation as one of the most versatile camera systems of our time. Its robust construction and absolute reliability have made it the favourite tool of the professional photographer who cannot afford any mistakes." (From a Canon brochure, 1977)

The Canon F-1 was launched in 1971. Its name was to be reflex camera number 1 and it was to show the world that the manufacture of professional cameras could also be achieved by someone other than Nikon.

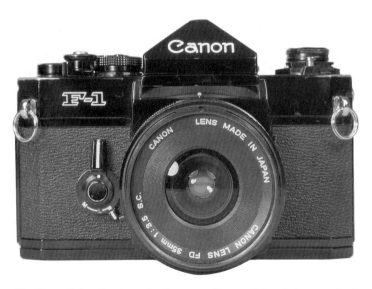

The Canon F-1, a slim streamlined camera with essential controls conveniently positioned.

The built-in exposure meter can be fooled - just as with any other camera - by the large dark area in the subject. Without correction this engine would appear grey in the picture. By turning the film speed dial towards the lower values the exposure can be adjusted as required.

Exposure metering - inside the body

The Canon F-1 is a comparatively slim camera which already includes an built-in exposure meter. No large separate exposure meter is required as the compact standard prism already allows exposure metering.

Since Canon recognized the sense of incorporating well-tried features into new cameras, the silicon photocell of the exposure meter of the F-1 is placed behind the focusing target and the required light is reflected from it. This principle was incorporated in the Canon FT but like the FTb the F-1 features an improved version. Light is diverted, from the centre of the viewfinder only, to the CdS exposure meter and the measured area appears as a darker zone.

The Canon F-1 therefore has a partial metering system by which the meter can be directed to the important subject parts quickly and accurately.

This advantage becomes very obvious when a subject with rather strong contrasts is involved. Either the various subject areas can be evaluated and an average value selected or a specific subject area can be chosen which corresponds to the standard subject with a reflectance of 18%. If necessary this standard subject can be brought into the picture with a grey card to which the exposure can adjusted.

As exposure metering occurs inside the camera only light passing through the lens is used. The focal length of the lens therefore has a bearing on the metering. The shorter the focal length and the greater the image angle the greater the area included in the exposure metering. In most cases this is a good thing, but there might be a time when, regardless of the way you hold the camera, you will always get a large part of a bright sky or a dark mountain range in the picture when photographing a landscape with a wide-angle lens.

It might be useful in such a case to substitute the wide-angle lens for one with a smaller angle of view for metering purposes. Set the shutter speed and aperture accordingly, then exchange lenses again (or alter the focal length of the zoom) and you are ready to shoot.

The FD lenses developed with and for the F-1 make it possible for TTL exposure metering to be achieved with wide open aperture and the FTb and all later Canon MF SLR cameras profit from this fact.

Working aperture metering with FL lenses or non-coupled accessories (like bellows) also presents no problem. Simply push the multi-purpose lever towards the lens to activate the stop down facility. The aperture closes, the viewfinder image appears darker and the exposure can be controlled via the aperture and/or shutter speed. There is no point in using FD lenses directly connected to the camera with working aperture metering.

Main switch - watch out for the "battery check"

The metering mechanism is activated by a small control knob at the back of the camera. It can be set to ON, OFF/FLASH and C (check battery). The ON position is only required for exposure metering. All other functions - aperture control, shutter control, film wind - require no electrical power, which sets the Canon F-1 clearly apart from the most modern cameras.

The exposure meter uses very little energy provided it is activated only when needed, but forgetting to switch off this function drains the 1.3V battery very quickly.

The battery is housed in the bottom of the camera and although the compartment lid is grooved a coin is probably needed to open it.

To make use of the C position of the main switch for a battery check, it is necessary to set the film speed to ISO 100/21° and shutter speed to 1/2000 sec. The needle in the viewfinder pointing to the battery check index then indicates whether there is sufficient power in the battery. The further down the needle is, the sooner you can expect the battery to be exhausted.

Take care, however, if the camera is loaded with a film of a speed other than ISO 100/21°. You can easily forget to reset the film speed ring to the correct value.

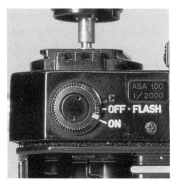

Pictures can still be taken with the main switch of the Canon F-1 in the OFF position. The ON position activates the exposure meter. The C position is for the battery check. It is important to observe the small sign.

Basically the battery check is not that important. The prudent photographer always carries spares around, especially when embarking on a long journey. And when the power runs out simply insert a new battery without actually checking.

Exposure control - tracking as standard

The principle of the exposure control of the Canon F-1 with a normal viewfinder is rather similar to that of the Canon FTb. Again the aperture or - more usefully - the shutter speed can be preselected and the second factor relevant to the exposure can be selected.

With a given film speed the position of the metering needle changes according to the prevailing brightness, or when the shutter speed wheel is turned. The match needle reacts to a change in the aperture setting. When both needles are aligned the exposure is correct.

That is - it should be correct. The camera cannot make any adjustments if the metering field was aimed at the wrong subject area. Therefore try to direct the meter as far as possible to that part of the subject corresponding to the medium grey of the standard subject and try to avoid including very light or

very dark areas in the metering field. The final picture represents very light or very dark subject parts as grey areas, i.e. the light part is underexposed and the dark part is overexposed.

During working aperture metering the match needle will disappear and only the meter needle will remain. This needle reacts to any change in shutter speed and aperture and must be adjusted to the working aperture metering field in order to achieve correct exposure.

Whereas all exposure information appears in the viewfinder on the FTb this information is displayed along the right edge of the viewfinder image on the F-1 and is therefore very clear and easy to identify. The exposure metering field as well as the setting aids have no detrimental effect on viewing the subject. The display area is bordered by incorrect exposure warnings at the top and bottom (top for over-, bottom for underexpo-

The viewfinder image of the F-1. The focusing aids and the 12% metering area for partial metering are in the centre. The exposure and shutter speed indicators are on the right.

The brownish wall was metered with the 12% metering area and the exposure selected accordingly. The light globes appear darker but they have not yet turned into silhouettes.

sure). When the working area of the exposure meter is exceeded the entire display area will turn red.

Beneath the display area the shutter speed can be read from a small window. The display area is illuminated by a small window to the left of the viewfinder prism roof. If the light is dim above the camera but bright in front of it (e.g. in the theatre or stadium) the subject is visible but not the display. In order to balance these conditions Canon offer a flash adapter which features a small light shining into the window.

The shutter - very fast but not always fast enough

The aperture setting depends on the attached lens, of course. Available are shutter speeds from 1 to a very fast $^1/2000$ sec (like the speeds of $^1/4000$ or even $^1/8000$ sec found in modern cameras, hardly ever used) which can be slowed down by means of corresponding accessories.

Although the shutter can achieve speeds of $^1/2000$ sec the synchronization time stops at $^1/60$ sec; no problem when a flash is used in the dark but more difficult with a fill-in flash.

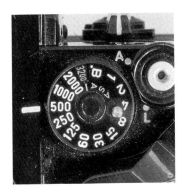

The shutter speed dial on the F-1 is engraved with shutter speeds from $^1/2000$ to 1 sec. Flash synchronization speed is $^1/60$ sec.

Film speeds - for all situations

Correct exposure metering naturally relies on the correct film speed setting. The film speed setting wheel of the F-1 is incorporated into the shutter speed wheel.

When the grooved outer ring is pulled up it can be turned without altering the shutter speeds. In the little window between the engravings "2000" and "B" you will find the film speed values.

The scale ranges from ISO 25/15° for fine-grained films such as Kodachrome 25 or Ektar 25 to ISO 3200/36°. High-speed films like 3200 T-Max are rarely used and even if you intend to utilize the variable film speed of Kodak Ektachrome P 800/1600 this is still possible. Of course, the EOS-1 or the EOS 10 offer a greater film speed range and are therefore of more long-term value - but only when high-speed films from ISO 5000/38° upwards are available.

Reflections can turn an ordinary subject into an interesting one.
Especially when the reflections in the water are upside down thus turning the subject the right way up again (page 44).

Features - clear and expandable

The EOS-1, the Canon professional camera of the 90's, offers the user a great many features which will rarely be used.

The Canon F-1 on the other hand whose weight is evidence of its solid construction was, as the professional camera of the 70's, rather meagrely equipped. Although many subjects can be included by adding accessories, the photographer must decide whether particular accessories really merit their purchase. And it must be said that a certain feature is more likely to be used to the full when the above decision has been made rather than built-in features that are only tried out once and then forgotten.

The F-1 on its own offers partial metering with open and working aperture, exposure control with a shutter speed range of 1 to $^1/2000$ sec (plus "B" of course) - all this you know. But what else has it got to offer?

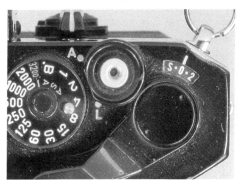

The most important controls of the F-1 are arranged on the right-hand side of the top plate. The shutter release button can also accommodate a cable release.

The shutter release...
...is threaded for the cable release, which is a very useful feature as the cable can simply be bought on its own. The Hama catalogue offers a wide selection, in various lengths, colours or with straight or angled end piece. They are so cheap that several can be bought to be carried in the camera case, be attached to a tripod and be kept near a small shooting table. The electronic remote release controls used with the modern cameras of today can hardly offer that.

The release can be locked by means of a small rotating switch. As the exposure meter is activated by its own switch the function of the release is really only to start the shutter process.

With the self timer...
...the release can be delayed by pushing the multi-purpose lever away from the lens to activate the self-timer facility. When the shutter release button is pressed, the lever starts to move and returns to its starting position with a humming sound. Exposure occurs after about 10 seconds. The lever will continue to run until it has reached its original position.

The L-M lever...
...underneath the multi-purpose lever can be set to three positions. In the basic setting - towards the lens - it is inoperative. In the "L" position the multi-purpose lever is locked in stop down mode; recommended for multiple exposures with working aperture metering. For example, it is a good idea to lock the multi-purpose lever in stop down mode when duplicating slides with a lens in reversed position on a bellows camera without FD connection, which already gives good results in conjunction with a modified Kaiser enlarger and an artificial light film such as Kodak Ektachrome 50 Tungsten.

Moving the small lever to the "M" position lifts up the mirror. The resulting dark viewfinder picture does not impede the exposure of stationary subjects which have already been focused. On the contrary, as the mirror movement has already occurred before the exposure is made, camera shake can be avoided which is an advantage especially when shooting close-ups or when using a very slow lens.

The flash connection...
...cannot be positioned on the top of the viewfinder prism as the viewfinder is interchangeable. The connection for the flash was therefore moved to the left and is perhaps unrecognizable as such.

The multi-purpose lever is pushed towards the lens to stop it down to the value set on the aperture ring. The lever can be locked into this position (L-M lever to "L") which is important for working aperture metering. The spring aperture lever in the lens bayonet, illustrated, must also be locked in the case of lenses such as the FD 35mm, f/35. Also clearly visible is the red dot indicating that no lens should be attached. When the L-M lever is set to "M" the mirror is up.

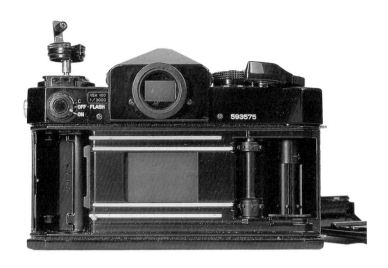

The film guide rails on the F-1 are long and improve the position of the film in the camera. The rubberised-cloth shutter reaches ¹/2000 sec. Flash synchronization speed is ¹/60 sec. The back cover is easily removable.

Top left of the camera body is the film rewind crank which can be capped with a flash adapter. Next to the prism is the window to illuminate the match needle of the viewfinder.

To use a clip-on flash, a flash adapter must be pushed over the film rewind knob in order to make contact with the camera.

Obviously the film rewind mechanism cannot be used in this position. If you intend to use a flash frequently you should buy a suitable flash shoe and connect the flash unit with a sync cable to the X socket located on the left side of the body. A well thought-out flash shoe is the Vivitar for the 283 flash, the Hama shoe 6835 with movable head is also recommended especially when the flash itself is not equipped with a movable reflector. When a very high-powered flash is required a hammerhead flash is a good choice as it already features a connection shoe and therefore does not interfere with the film rewind mechanism.

An easy way out is to try and find a Speedlite 133 D or Speedlite 500 A for your F-1 as you will then have the option of using CAT control with two normal lenses and two wide-angles and you can profit from the automatic guide number selection when using flash.

The film rewind...

...is not very large but is big enough to operate with gloved fingers if necessary. When the film is rewound a soft whistling sound can be heard while there is still some film on the take-up spool. If you prefer not to rewind the film leader into the cassette simply stop rewinding as soon as the sound ceases. If

In order to pull up the film rewind crank to open the back cover, a small button must first be pressed. On the left of the body is the connection socket for flash sync. cables.

the sound cannot be heard because of a noisy background, check the rewind release button at the bottom of the camera body. This button is marked with a small dot so you can see if the release button and the roller spool are still revolving.

To remove the film from the camera press a small button in front of the rewind knob, before this is pulled up to open the camera back. This additional safety feature arose out of the demand of many professional photographers who were afraid of inadvertantly opening the camera and thus ruining an exposed film. This is a particular hazard when several cameras are used at the same time.

Interchangeable viewfinders and focusing screens - see better, focus better

Viewfinder and focusing screen of the Canon F-1 can be changed simply and quickly - if you are lucky enough to find these articles nowadays.

Including the standard prism, there were five different interchangeable viewfinders available for the F-1.

For a compact camera the standard viewfinder is the right choice. The Waist-Level Finder, when closed, adds very little height to the camera. When opened, you look down onto the focusing screen, where the image appears upright, but reversed left to right. When working with a copying stand, the support column of an enlarger for example, the waist finder is

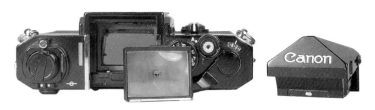

The user can change viewfinder and focusing screen quickly and without special tools.

The clear viewfinder image allows converging verticals to be recognized before shooting and used to special effect. This crane has been made to look even taller by the use of a 20mm lens.

a wonderful feature. The fivefold magnifying viewfinder makes focusing on small subjects quick and easy. Exposure metering will not operate with this viewfinder, however, as there is too much light falling from above on to the screen to achieve accurate results.

The Speed Finder is considerably larger and can be used for a wide range of applications. It has two advantages; one, the exit pupil lies about 6cm behind the eyepiece, i.e. viewing is possible even when wearing goggles or safety helmets. This viewfinder is not strictly necessary for wearers of ordinary spectacles as the standard viewfinder is quite suitable; two, the viewing angle can be altered. The F-1 can then be used at eye-level or at waist-level, or with a low-set tripod or the copying stand. Exposure metering is possible with this viewfinder.

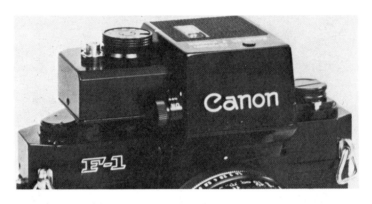

The Booster T Finder increases the metering range in the low light region of the Canon F-1.

The metered area of the built-in exposure meter covers the exposure values 3 to 19 (EV 3 - EV 19) when a film of ISO 100/21° and an f/4 lens is used. If you frequently take photographs in low light and these values are insufficient you might try to get hold of a Booster T Finder.The camera's exposure meter continues to function if there is enough light. Metering is partial and shutter speeds between 1/60 and 1 sec can still be set while fast speeds of 1/125 sec to 1/2000 are no longer possible. The booster's own shutter speed ring is marked with the speeds from 1/60 to 1 sec in white. The orange markings represent the slow speeds which are available from 3 to 60 sec for use in low light. Now the exposure is metered by the metering system of the booster, not partially this time but integrating the central area and with working aperture. The booster not only increases the shutter speed range but also the range of film speeds up to ISO 12800/42° which should be sufficient for some years.

The largest interchangeable viewfinder is the Servo EE Finder which converts the manually controlled F-1 into an aperture controlled camera. Shutter speed is selected on the setting wheel of the viewfinder from the same range as the one used by the speed wheel of the camera. The camera then

The Servo EE Finder turns the Canon F-1 into an automatic camera. The aperture is set automatically which requires a mechanical coupling between viewfinder and lens.

determines an aperture suitable for the shutter speed and sets it on the lens. To that purpose the viewfinder is coupled to the aperture control lever of the camera and a small slot is provided to the left of the lens mounting which is normally covered. This finder is powered by an external battery pack or the motor driver unit turning the automatic F-1 into a rather cumbersome piece of machinery which was never designed for the amateur market. The automatic F-1 with Servo EE Finder and motor was intended to give the journalist, used to carrying heavy loads around, more safety when shooting quickly and to enable the scientific photographer to make fully automatic exposure series. Reporters and scientists also had 250-frame magazines and large and expensive time-lapse program equipment at their disposal. A data back was added to the system later.

The range of focusing screens was gradually increased to nine:

A with microprism ring, suitable for all subject areas. Not recommended for use with lenses of f/5.6 and slower as the grid darkens the image.

B with split image indicator, areas of application as A.

C all matt without focusing aids. For all subjects unsuitable for microprisms and split image wedges (e.g. macro, micro or astro photography) and for slow lenses to be focused on the screen.

D matt with grid division, suitable for architectural and copying where exact alignment of the camera is imperative.

E with microprism ring and a split image indicator as in A and B for universal use with average lenses.

F with microprism ring, designed for very fast lenses.

G with microprism ring, designed for lenses of f/3.5 and slower.

H matt with image scale for photography where the exact specification of the image ratio is important.

I with double reticle for specialist subject areas such as astro photography.

Motor drives and winders - from a quick repeat shot to a picture series

The camera motor drive was a characteristic of the professional camera - at least in the opinion of a lot of amateurs glancing wistfully at those great, heavy and noisy things.

Professional photographers look at it in a different way. There is no need for a motor when shooting a lot of architecture or landscapes but it becomes indispensable when shooting fashion, sports or political events.

Consequently some professionals bought a motor, others did without. This decision could be avoided with the Canon F-1 as its motor drives are connected to the camera (only possible when no film is loaded as the entire base of the body has to be removed).

When the F-1 was launched there was a choice of two motor drives. The universal Motor Drive Unit MD features a built-in timer for interval exposures and can move up to 3 fps. The hand grip is fixed underneath the motor and equipped with a release button. The drive is powered by an external power pack and is suitable for technical and scientific subjects.

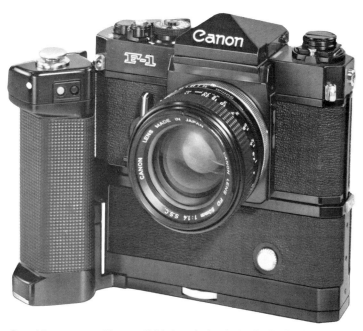

One of the two motor drives available from the beginning for the F-1: Motor Drive Mf with release in the hand grip.

The Motor Drive MF looks like modern winders and drives. The actual motor part is screwed into the base of the camera, the hand grip is positioned at the front right making its use simple and easy. The hand grip is removable. Both units are connected by a cable and the hand grip turns into a remote control. The shooting frequency of 3.5 fps seems rather slow compared to modern motors giving 5 fps. But frequencies like that are rarely necessary apart from in sports or animal photography and a MF is quite adequate.

Shortly before the F-1N replaced the F-1 a third motor drive was introduced, the Power Winder FN. It is able to transport the film at 2 fps. For vertical and horizontal frames there is a release on the hand grip and one on the motor part. 2 fps is quite fast enough for short series of children or animals at play. But more important is the facility to keep the camera to the eye while the film is wound on immediately after exposure cocking the shutter at the same time. In this way you can react quickly to a change in the subject, e.g. when the child suddenly pulls a face or when a passer-by intrudes just when you are about to shoot.

Canon EF - Automatic to the End

"Canon's range of SLR cameras has had an addition - a top of the range automatic camera. An automatic camera in which Canon did not simply automize existing features." (From a Canon brochure, 1976)

When the Canon EF was introduced in 1973, automatic exposure control was still fairly uncommon in a high-quality SLR, and cameras featuring some form of automatic control were also the subject of heated discussions at the time.

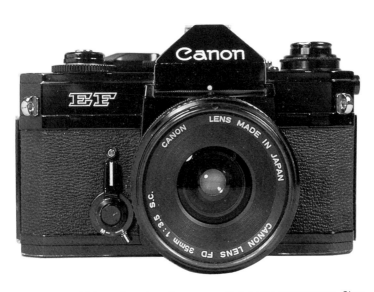

Canon EF - a high-quality automatic camera with hybrid control system. Slow speeds are controlled electronically, fast speeds are controlled mechanically and are thus independent of the batteries.

*Old trade signs of pharmacies, pubs or shops provide a fascinating subject area.
As the background is usually the sky there could be exposure problems - but
they can be solved easily with the AE memory button of the EF.*

Automatic exposure control - which type?

Some people swear by shutter priority as this type is easier to construct than aperture priority. The camera automatically sets the shutter speed and all necessary elements are already present in the camera body. The aperture is preselected as usual and closed according to the manually-set value. The creative aspect is also catered for. The aperture in conjunction with focal length and image magnification controls the extent of the depth of field, and the correct distribution of sharpness is very important for the picture. If the aperture is preset and the shutter speed is controlled automatically, the photographer can adjust the depth of field exactly.

On the other hand many people prefer aperture priority. The photographer selects the shutter speed and the camera sets the corresponding aperture. This process is more complicated than automatic shutter speed control but the advantages are obvious. One is the fact that the focus is always directed to the important subject part, i.e. irrespective of the depth of field the important part of the picture is always in focus. Preselection of a fast shutter speed according to the focal length reliably prevents the sharpness being ruined by camera shake. In addition, the shutter speed also plays its part in the composition of the picture. Fast shutter speeds freeze movements, slow speeds blur them creating a more dynamic picture.

Aperture priority - the choice of many speeds

Having selected this method of priority for the F-1 and the Servo EE Finder, the Canon EF also features this type of automatic control.

The shutter speed is set by turning the EF's large shutter speed wheel which is conveniently grooved and projects from the front edge of the camera body. It is much easier to manipulate when the camera is at eye level than it is with the shutter speed wheels of the FTb or the F-1.

The setting wheel of the EF has 17 positions. The fast and medium speeds of $^1/1000$ to 1 sec and B are marked in white; the slower speeds of 2 to 30 sec are marked in yellow. The exception is the synch speed of $^1/125$ which is clearly marked in orange.

The different colours not only concern the speed of the shutter but also its control. The white speeds and the $^1/125$ sec are controlled mechanically and function even without a battery. The yellow speeds are controlled electronically adding a great deal of accuracy, although they cannot be used when the battery fails. But considering how rarely these speeds are actually needed...! As the batteries naturally fail just at the time when you need an exposure of 15 sec it might be safer to carry spares around or a watch with a second hand as the "B" setting can be used on the Canon EF without a battery.

Once the shutter speed has been the selected the EF automatically selects the correct aperture, provided the lens offers it. If the aperture range is too small the camera warns of impending over or underexposure.

Automatic aperture control only functions, however, when the aperture ring is set to the Auto mark - a green circle for the older FD lenses, a green "A" for the newer ones.

Shutter speeds ranging from 30 to $^1/1000$ sec are selected by the large shutter speed dial which protrudes from the front edge and is thus easily operated when the camera is at eye level. The yellow figures represent the slow shutter speeds which are controlled electronically.

Aperture priority is selected by bringing the aperture ring into the automatic position. In this case manual stopping down to test the depth of field is not possible.

The red LED to the left of the viewfinder prism indicates that the shutter is still open during exposure at the slower speeds. The LED also serves as battery check indicator.

During exposure with a yellow speed a red LED at the top of the camera flashes indicating that the shutter is open. The flashing light is very useful when shooting with slow speeds using a tripod and if, because of a noisy background, the click of the shutter cannot be heard.

Exposure metering

The Canon EF is equipped with a main switch. Conveniently located underneath the winding lever it can be operated with the thumb even when the camera is at eye level. This means that the subject can first be scrutinised through the viewfinder. Then, with the camera at the eye, push the main switch upwards to activate the exposure meter. The camera only starts to use energy at this point. Naturally the main switch can be left in the "ON" position in order to be able to shoot quicker. The batteries will not be drained immediately. Especially when you are out hunting for a good shot the camera should be switched on as the shutter is blocked when the main switch is in the "OFF" position. As soon as it is switched "ON" the winding lever is in the ready position and sticks out sufficiently from the camera body to provide enough space for your thumb.

Exposure is metered through the lens (TTL) and normally involves a wide open aperture (open aperture metering) although working aperture metering is also possible.

Metering of the working aperture with FL lenses works in the same way as with the FTb or the F-1; by setting the aperture on the lens and pushing the stop-down lever towards the lens. If necessary it can be locked in this position. If you want to

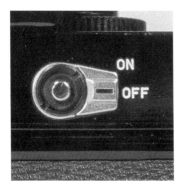

When the picture has been composed in the viewfinder the main switch can be brought into the ON position by using your thumb. This also conserves energy.

The metering characteristics of the Canon EF is centrally integrated - just right for correctly exposed quick snapshots with an automatic camera.

meter the exposure with working aperture using FD lenses, with attached uncoupled accessories between camera body and lens, you first need to adjust the lens and then lock the spring aperture button on the reverse side of the lens. This is the largest button on the bayonet. After turning the aperture ring from the A position push the button against the resistance of a spring towards the other end of the guide groove where it will engage or where it must be locked in the case of some lenses by means of a small slide. I strongly advise against working aperture metering with directly attached FD lenses.

Exposure metering does not occur in the usual 12% metering field but is centre weighted integrating metering which is a pity at first glance as no doubt partial metering is very accurate

The exposure value can be stored by means of a small chromium button to the left of the prism - a useful feature that is fairly easy to operate. The marking behind the button indicates the film plane which can be used to focus macro shots precisely.

for many situations. But having to aim the metering field at the main subject first is contrary to the function of a fast automatic camera.

Centre weighted integrating metering enables the photographer to raise the camera, switch it on and release the shutter. Just remember to wind on the film after the last shot, cocking the shutter at the same time. The EF has no motor and unfortunately a motor or winder cannot be attached.

The element responsible for rapid metering in the EF is silicon. Like selenium, silicon also produces energy when exposed to light. This energy, however, cannot directly be used as a power source for exposure metering - hence the need for a battery back-up.

Wide-angle or super wide-angle lenses help to include all of tall churches or castles into the picture.

The selected shutter speed and automatically set aperture can be seen in the viewfinder. If you are not satisfied with the combination given - for an overall light or dark subject or a backlit situation, for example - you can quickly correct the exposure. Look for a substitute subject covering several well-mixed areas of brightness and thus approaching the 18% grey value to which the EF's exposure meter is also set. Another option in the case of a backlit subject is to meter from close up. The new value can be stored by pressing the AE memory lock button to the left of the viewfinder prism. This button could have been positioned more conveniently but once you get used to it you will be able to operate it quite quickly.

(Top): Wide-angle or super wide-angle lenses could include too much of the foreground, however, but as long as a crowd of tourists fill the space an extensive foreground is no problem.
(Bottom): Fisheye lenses - unlike super wide-angles - depict straight lines as curves.

The film speed is set on the dial. A film reminder clamp can be stuck to the camera's back cover to remind you of the film loaded. The highest film speed that can be set is ISO 3200/36°.

Film speeds - practice-oriented and adequate

The film speed wheel surrounds the film rewind crank. It must be lifted slightly for film speeds of ISO 12/12° to ISO 3200/36° to be set in one-third steps.

The film speed setting wheel of the EF (and of the FTb or F-1 as well) can be used to correct the exposure or to adjust the exposure meter to the particular film loaded.

A higher ISO value than given by the film will result in a shorter exposure, i.e. when it is impossible to take a substitute evaluation in the case of a very dark subject you could expose Ektachrome 100 as an ISO 160/23° or ISO 200/24° film to retain the general dark character of the picture.

When the subject is very light or backlit you could use the same Ektachrome 100 with an ISO 64/19° or ISO 50/18° setting to achieve a more generous exposure.

The difference obviously varies from subject to subject and even the experienced photographer would be wise to make an exposure series in sets of three in order to get the correct value.

For that reason exposure compensation can be made via the film speed as unlike aperture and shutter speed it can be controlled in one-third steps. To be able to notice such fine differences, however, you need a slide film. There is no point making compensations of this magnitude when a Kodacolor Gold negative film is loaded whose exposure latitude is very wide.

The precise adjustment of the film speed to the exposure meter is also only appropriate when a slide film is used. For example, Ektachrome 200 can be used like an ISO 250/25° film to achieve richer colours or Kodachrome 64 like an ISO 50/18° when softer colours are preferred.

The viewfinder - more informative than ever

The viewfinder of the Canon EF gives all kinds of information. The focusing screen has a split-image microprism rangefinder in the centre to aid fast and accurate focusing. With slow lenses - from f/5.6 - a darkening of the prisms or of one of the prism sections occurs. However, this can be minimised by trying to look into the viewfinder absolutely straight and centrally. This problem was quite common when the Canon EF was introduced - and many cameras still have it today.

The smooth edge of the viewfinder image is broken by a small notch at the bottom right, forming the setting index for exposures with working aperture.

The viewfinder of the Canon EF is eminently clear and informative. All information regarding aperture and shutter speed, as well as over- and underexposure warnings, are displayed outside the viewfinder image.

All other information is located outside the actual viewfinder image.

The aperture scale is vertically situated at the right edge and limited at the top and bottom by red areas. The upper red area and the aperture scale are movable and change according to the aperture of the lens used. With an FD 35mm,f/2.8 lens you can see an aperture range of 2.8 to 22, with an FD 17mm,f/4 a range of 4 to 22 and with an FD 75-150mm,f/4.5 a range of nearly 4 (corresponding to 4.5) to 22 although this zoom lens can be stopped down to f/32. But the display is not geared to smaller apertures than f/22.

The red areas not only limit the aperture scale but they also function as the exposure error warning system (overexposure at the top - the aperture cannot be closed far enough; underexposure at the bottom - the largest aperture is insufficient).

Underneath the viewfinder image is the display area with the scale of speeds from $1/30$ to $1/1000$ sec: the filled-in black numbers represent fractions of seconds. A fork shows the shutter speed selected. You therefore always know which shutter speed and aperture are controlling the exposure.

When the camera is switched on, the film advance lever will move into the ready position. The shutter release button can accommodate a cable release.

70

Other features - well thought out and user friendly

The film advance mechanism...
...is large and easy to operate. It is in the ready position as soon as the camera is activated. Once the film is loaded just operate the film advance lever three times to transport the film to the first frame. There is no need to press the shutter release which is useful although the question arises why the quick-load feature of the FTb was not adopted for this camera.

The multiple exposure button...
...occupies the position which should be held by the AE memory lock button from the point of view of user friendliness. It forms the axis of the main switch and is thus within reach of the right thumb. The Canon EF cannot be changed any more and you just have to live with the fact that the AE memory lock button is more difficult to reach than the multiple exposure button.

What is its function?

Multiple exposure can turn an average subject into a fantastic picture. Just think of a line of backlit palm trees on the beach which are reduced to a silhouette in the viewfinder with a pale blue sky above. You know that you can only get the whole scene on your Ektachrome 100 with the help of a wide-angle lens and you also want to include a giant full moon hanging

The small button in the axis of the main switch uncouples the film transport from the shutter mechanism for multiple exposures.

above the palm trees. But the moon is not in the right position and it would only be depicted as a pin-head by the wide-angle lens anyway. You can still achieve the picture you envisage by making a double exposure. Superimpose a shot of the moon in the position you want it over the wide-angle picture using, say, a 300mm plus 2x Extender which enlarges the image to about 6mm on the negative.

This can be done quite easily with the EF. Take the first shot, press the multiple exposure button and only then activate the film advance lever. The film wind mechanism is now inoperative and only the shutter is cocked for the next exposure.

You can do this three or four times but remember that the final picture could look quite chaotic with all those individual subjects.

The flash shoe...

...and the sync terminal are possibly more essential than the CAT switch. This is only used when the Speedlite 133D or 500A and a lens with the CAT facility are attached. In this situation the CAT switch (at the back left) must be turned to the flash symbol and the aperture ring of the FD lens be brought into the automatic position. The flash unit then informs the camera of its guide number and the lens of the distance set. The focus rings of four lenses (FD 50mm,f/1.4; FD 50mm,f/1.8; FD 35mm,f/2 and FD 35mm,f/3.5 - all with

The hot shoe features a contact for use with normal flash units and two further contact points for CAT system flash units.

On the left side of the camera body is the connection for the flash sync cable. It has a protective cover to keep out dirt.

chromium ring) are equipped with carrier pins for that purpose. The front bayonets of these lenses which normally take diffusing apertures can be fitted with Flash-Auto Rings which sense the distance from the carrier pins. This value is then fed into the camera electronics and the correct flash aperture can be calculated from guide number and distance - according to the rule "aperture equals guide number divided by the distance". This is how the Canon EF operates and the camera sets the respective value on the lens.

All flash units featuring a hot contact can be fitted to the flash shoe, although it is not always guaranteed that the trigger voltage of the Canon EF and that of ultra-modern flash units are compatible. Normal computer flashes can always be used.

If the output of the clip-on unit is insufficient a hammerhead flash can be connected to the sync terminal located on the left side. It has a flexible cover to protect it against dirt and dust.

The idea of TTL flash control was still a thing of the future when the Canon EF was introduced and it is therefore necessary to work according to the guide number calculation with computer or manual flash units. In this case the use of computer flashes is preferable. Unlock the aperture ring, set it to the computer flash aperture and remember to set the same aperture on the flash. The sensor of most computer flashes is unfortunately sited quite a distance away from the lens, especially in the case of hammerhead or clip-on units which are

attached to a hand grip to prevent the well-known "red eye" effect. A flash such as the Vivitar 283 whose sensor can be used separately from the flash would make a suitable addition to the Canon EF. The sensor is attached to the camera's hot shoe and the flash to the hand grip which is connected to the camera's sync terminal by a cable.

The red LED...
...next to the viewfinder has already been mentioned in connection with the slow shutter speed. The light emitting diode not only flashes during slow speed sequences but also when the red battery check button at the base of the camera is pressed. The LED flashes frantically when there is sufficient power and slows down when the power is running out.

The self-timer...
...like on the FTb and F-1 is combined with the depth of field preview/stop-down metering lever. Turning the lever downwards and then releasing the shutter starts the self-timer mechanism. Exposure occurs about 10 seconds later. As the mirror has already been lifted when the shutter release button was pressed this turns the self-timer of the Canon EF into a good substitute for a cable release when used with a tripod. By the time exposure is actually taking place any vibration caused by pressing the shutter release and by the mirror movement will have ceased and there should be no danger of camera shake. Obviously the tripod also has a part to play in this.

The depth of field preview/stop-down metering lever...
...is rarely used in connection with metering in working aperture. You probably would not want to miss the convenience of FD lenses and open aperture metering offered by the Canon EF.

But the depth of field preview lever is useful. If you want to compose a picture by the aperture, i.e. by the extent of the depth of field, a look through a stopped-down lens at the subject is important. Turn the aperture ring of the FD lens from its auto position and set the aperture. When the depth of field

preview lever is turned to the left the aperture closes and the depth of field can be seen in the darkening viewfinder image. In theory this could be done with all apertures but in practice the visual evaluation of the depth of field is limited by the darkness of the viewfinder image.

The depth of field preview lever can also be locked into position by turning the L-M lever underneath it to the "L" position.

The L-M lever...

...underneath the depth of field preview/stop-down metering lever also shows the position "M" representing "mirror up". This is for exposures with large image magnifications in macro photography or with very long focal lengths although there should have been enough time for any vibrations to be eliminated during the self-timer sequence.

Moving the mirror up manually is connected to working aperture metering and locking the stop-down metering lever in the appropriate position. For this FD lenses must also be locked by the spring aperture lever.

Canon AE-1 - The Beginning of a New Era

"Even if technology has recently surprised us again with more innovations - the AE-1 is just as attractive today as it was when it first came on the market. A high-quality SLR camera with automatic exposure resulting from the marriage between electronics and precision engineering - a camera whose design, manufacture and final control have been automated to an extent unheard of until now. The AE-1 does indeed herald a new era in camera design." (From a Canon brochure, 1980)

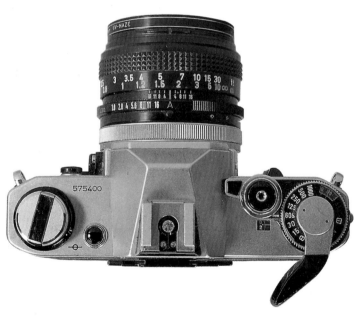

The triumphant introduction of electronic cameras began with Canon AE-1 and for the first time peripheral gadgets such as flash units and winders were included in the controls provided on mass-production cameras.

The AE-1 marks Canon's change from the second generation SLR cameras (FT, FTb, TLb, F-1) to those of the third generation. All the advantages of the single lens reflex camera system, e.g. the use of a good range of accessories and especially many different lenses as well as the facility to see the subject through the viewfinder as it will appear on the picture, are also evident in the AE-1. It has its own range of accessories, is integrated in the Canon system and offers a clear viewfinder image whose size is quite unexpected. Finally the Canon AE-1 is a compact camera, easy to hold and the roof of the prism viewfinder does not protrude unduly from the upper cover of the body.

The viewfinder - not quite complete

The viewfinder image is quite clear and well-laid out. The setting aids are located in the centre; a horizontal split-image microprism ring rangefinder. Both still feature the same mistake and darken the image when the aperture is f/5.6 or smaller. The problem can be minimized only by looking through the viewfinder absolutely straight and centrally. Very slow lenses are rarely found in the Canon FD system, except among the long telephotos.

The screen of the Canon AE-1, like the cameras of the F generation, features a Fresnel lens ensuring a bright and evenly-lit viewfinder image. The characteristic circular ridges are invisible and pose no obstruction even when the lens aperture is closed.

Although the Canon AE-1 offers shutter priority unfortunately the shutter speed selected is not displayed in the viewfinder. The aperture scale is positioned to the right of the viewfinder image indicating f/numbers from f/1.2 to f/22. The upper edge of the scale is occupied by a red area divided in two and even when the f/number is 5.6 a dark marking is still visible.

The aperture automatically selected by the camera is indicated by an needle over the aperture scale. Whenever overex-

posure threatens it points to the overexposure warning areas according to the minimum aperture of the attached lens.

Impending underexposure is clearly indicated by a red LED underneath the aperture scale. This LED also shows when the metered area has been exceeded. The fact that no LED appears above the aperture scale when overexposure is indicated remains unexplained. This could become a problem when the lens can only be closed up to f/16 and the overexposure warning could also be interpreted as the indicator for f/22. One cannot always remember the smallest aperture of the lens being used.

A red "M" will flash above the scale when the aperture is set manually which might be the case when you want to check the depth of field in the viewfinder by stopping down the lens. The red "M" is also displayed when exposure is metered with working aperture (which should only be done with FL lenses or other accessories not intended for open aperture metering).

The index mark is particularly important for working aperture metering - with FL extension rings or older bellows - around f/5.6. To achieve correct exposure the needle must be made to coincide with the index mark.

Exposure metering - fast even in low light

The exposure meter of the older Canon EF featured a silicon cell reducing the time of response on the one hand but allowing accurate metering even in low light on the other.

So it comes as no surprise to find a silicon cell in the Canon AE-1, giving it a metering range of EV 1 to EV 16 (with ISO 100/21°).

Metering is centre weighted integrating which allows fast shooting but could lead to problems in difficult lighting conditions. Such a situation might be a landscape with a large area of sky or a portrait outdoors. Although the emphasis is more towards the centre, the bright sky could still influence the exposure meter unduly. The result is a bright light value leading to insufficient exposure for the whole picture. The landscape

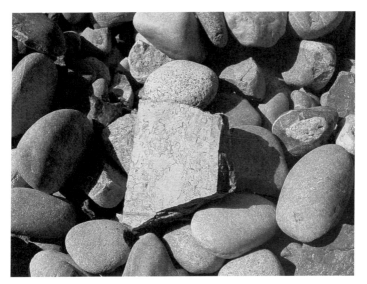

The contrast between the single angular stone and the many round pebbles is asking to be photographed. The different grey shades of the stones resemble the 18% grey to which all exposure meters are adjusted.

or the face which were supposed to be the important part of the picture appears too dark. Canon has managed to overcome this problem almost if not completely. The exposure metering zones of the AE-1 were compressed a little. Now the centre determines the metering more, the lower parts of the picture less and the upper part has only very little bearing on the result.

The exposure meter of the AE-1 is no longer activated by the main switch. It suffices to press the shutter release down to the first pressure point to close the respective power circuits. Exposure occurs when the shutter release is pressed down fully.

Automatic control - fast, safe, easy

The Canon AE-1 features shutter priority already known from the Canon EF or the Servo Finder EE from the Canon F-1.

You select the shutter speed on the shutter speed selector dial according to the subject and the f/number of the lens in use. The camera determines a suitable aperture and sets it on the FD lens whose aperture ring must be in the automatic position.

Twelve different shutter speeds are available - from 2 to ¹/1000 sec.

All speeds are controlled electronically and are therefore not available without a battery. It is a good idea to carry spare batteries as the Canon AE-1 is completely useless without

The shutter speed selector dial is flush with the camera body and thus not as easily operated as that of the Canon EF. The speeds range from 1 to 1/2000 sec. A guard around the back prevents inadvertent alteration of the dial when the film advance lever is operated.

The Canon AE-1 is powered by a 6V battery.

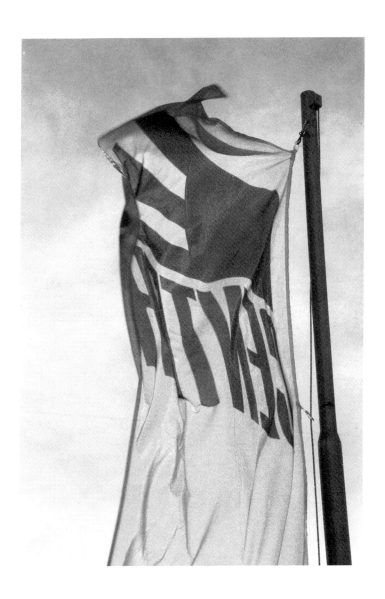

By preselecting a suitably fast shutter speed, the flag flapping in the strong wind can be photographed with hardly any blur caused by movement. No problem for automatic exposure, either.

power. Whereas F-series cameras only needed button cells, the AE-1 requires a 6V silver oxide battery as a power source for its many electronic features.

The shutter speed selector dial is positioned on the right of the camera top plate with the film advance lever on its axis. Regretably the selector dial does not protrude from the camera body and therefore cannot be operated as easily as on the EF, but at least it is milled and easy to turn.

Automatic exposure control works quickly and accurately and can handle a wide range of lighting situations. Difficulties arise, however, when the subject is obviously backlight - a tree before a very bright sky or a portrait in front of an open window will appear as a silhouette.

For situations like this the Canon AE-1 is equipped with an backlight control switch located within reach of the left thumb to the left of the lens mount. First, half release the shutter to activate the exposure meter. At the same time the aperture the camera would select appears in the viewfinder. When the backlight control switch is pressed as well you can see in the viewfinder an aperture one-and-a-half stops larger than chosen by the automatic control. The subject is clearly exposed more generously and the tree will look right again - although the background will be overexposed.

The backlight control switch with its programmed plus compensation of 1.5 aperture stops is quite convenient when you are in a hurry but certain subjects merit a more complicated exposure compensation.

The switch underneath the shutter release has several functions. When pulled back the shutter is blocked and no power is used - important when the camera is tightly packed in a bag. Pushed forwards the switch serves as a self-timer release, delaying exposure by 10 seconds. When used correctly it can also function to store the exposure value.

The best solution would obviously be a reduction of the difference in brightness between the background (very light) and the main subject (dark). In the case of the portrait you could reflect the light on to the face by using a white sheet of cardboard or aluminium foil to achieve a proper lighting balance. One further step would be to aim exposure entirely at the main subject. Move closer or select a longer focal length to avoid the background being included in the metering. The value thus reached can either be read off the viewfinder display and set manually at the lens or it can be stored.

Although the camera was not designed to store a metered value this can be achieved by using the self-timer. This is one of the functions of the main switch, situated under the shutter release. Turned towards the camera back it locks the shutter release, turned forward it activates the self-timer which operates electronically. Pressing the shutter release starts the self-timer - and the metered exposure is stored for 10 seconds. That

means that you can activate the self-timer, take a substitute reading - from the important subject part or from a subject part corresponding to the 18% average subject - and store the result by pressing the shutter release. Now the image section can be determined again and you either wait until the self-timer has run down, about 10 seconds, or you return the main switch to the operating position which will immediately result in an exposure being made with the aperture stored.

Naturally you could also correct a back-lit situation using the same method without directing the light to the main subject first. In this case the main subject will again be exposed correctly with the background too light. Storing the metered value is also important in other difficult situations, especially when a grey card is available as reference. Such grey cards are available from Kodak or Hama.

Another compensation option is changing the film speed, which must also be done manually in the AE-1.

Film speed - quite fast enough

Input of the film speed is once again coupled to the shutter speed selector dial. The dial is pulled up against slight resistance and then the desired film speed can be set. The range extends from ISO 25/15° to ISO 3200/36° and includes all speeds required for normal photography plus a few more.

Film speeds are selected by lifting and turning the film speed dial and the set speed is visible in the small window.

The back cover of the Canon AE-1 can be exchanged for a data back. A memo holder is standard and holds the top of the film carton.

When the camera is taken up again after some time the film type is easily forgotten. Although you can read off the film speed from the film speed dial, the ISO 100 film loaded might be a black-and-white T-Max, a Kodacolor Gold for colour photos or an Ektachrome 100 for colour slides.

The AE-1 has a convenient memo holder on its back. Simply remove the top of a film carton and insert it into the holder and you can easily remember which film is loaded. Just don't forget to change the label when you change the film! Memo holders are very useful. Self-adhesive versions can be bought separately for other cameras.

But what do you do when the memo holder is empty but a film is loaded? Simply rewind the film very carefully remembering the frame number. Watch the white dot on the rewind knob. As soon as the white dot stops revolving stop rewinding the film. Now only the film leader will protrude from the film cassette. Open the camera back by pulling up the rewind crank and you can see which film is loaded. Reload the film in the

The film must be rewound manually, by first pulling out, and then turning, the film rewind crank.

normal way by threading it in the multiple slot spool, close the back cover - which is removable and can be exchanged for a data back. Next, close the aperture to its smallest stop, select the fastest shutter speed of $^1/1000$ sec and make one exposure after the other - with the lens cap on - until you reach the frame number last used. This will prevent any damage through light reaching the already exposed film.

Page 87: There are two kinds of filters. Correcting filters improve the picture technically. In the case of the pictures on the right the Cokin Polarizing Filter achieved richer colours, although a 100% effect could not be achieved due to the position of the sun.

Page 88/89: The series of focal lengths show that a detail can be picked out from an overall view. The pictures were shot with two fixed focal length lenses (FD 17mm,f/4; FD 24mm,f/2.8) and three zooms (FD 35-70mm,f/4; Series 1, 70-210mm,f/2.8-4 and Series 1, 100-500mm,f/5.6-8). The Ektachrome 200 gave two moderate shutter speeds and a tripod ensured that after the lens change the camera remained in the same position as before.

17mm

24mm

70mm

100mm

200mm

300mm

50mm

135mm

500mm

mm

0mm

0mm

Additional Features - a good range

The battery check button...

...is located between viewfinder prism and film rewind crank the top of the camera. It is larger than expected for its quite minor function. When this button is pressed while the self-timer is in operation the sequence will be interrupted. It is restarted by pressing the shutter release unless the self-timer button is not reset first.

The exposure preview switch...

...is found underneath the backlight control switch to the left of the lens mount. This can be distinguished with the fingertips quite easily - the backlight control switch is small and raised, the exposure preview switch has a larger diameter and is flatter. The latter switch is used to activate automatic exposure and exposure metering without pressing the shutter release.

Creative filters change the picture, making it more interesting. This is shown by the Cokin Diffuser 2 and tobacco graduated filter.

575400

This facility can be used when you wish to shoot with a particular aperture in order to increase the depth of field to a certain extent. The right index finger turns the shutter speed selector dial until the needle in the viewfinder display points to the desired aperture.

As the AE-1 has no speed shutter display in the viewfinder I recommend visually checking it. Otherwise the hand-held limit is easily exceeded and you have camera shake.

The rule of this limit states that the shutter speed should not be slower than "One divided by the focal length in mm" in order to avoid camera shake when pictures are taken hand-held with this focal length.

Below the backlight control switch is the exposure preview switch, used to activate the metering mechanism. The right hand remains free to operate the shutter speed dial.

The stop-down lever is located at the front of the body. When pressed, a red dot in the bayonet warns you not to attach a lens.

In any case, it is better to utilize the automatic aperture setting as featured by the Canon AE-1 to preselect faster shutter speeds. What is the use of a large depth of field coming from a small aperture when the picture is blurred?

If a certain depth of field must be achieved by means of a small aperture and a correspondingly slow shutter speed it is advisable to find a sturdy support for the camera. A good tripod such as one from the Cullmann Titan series is very important here. Pocket tripods such as the Cullmann magic 2 are also useful provided you know the limits of such a mini tripod.

The AE-1 features a socket for the connection of flash units with a sync cable.

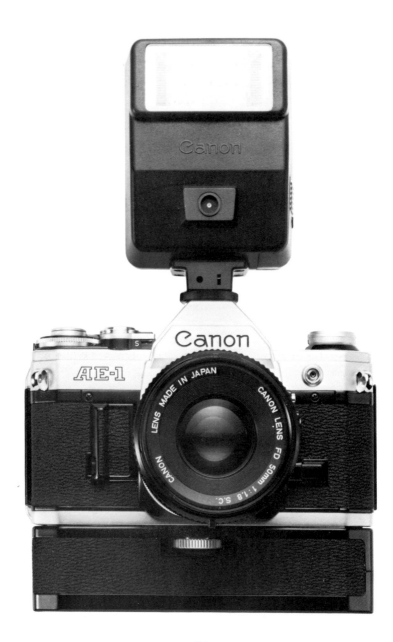

The stop-down lever...

...on the Canon AE-1 is not coupled to the self-timer switch as in the F series cameras but can be found by the thumb of the left hand, while supporting the lens from underneath. The lever can be locked in its working position and unlocked again by pressing a small button which appears when the stop-down lever is activated.

But simply pressing the stop-down lever is not enough to close the aperture to check the extent of the depth of field in the viewfinder.

First the aperture ring of the lens must be turned from the automatic setting and the aperture selected at which the depth of field needs to be evaluated. If the aperture is very small you can save yourself this operation as with f/16 or even f/22 the viewfinder will appear too dark to differenciate between sharp and unsharp anyway.

In this case use the depth of field scale on the lens instead.

The PC socket...

...on the left front of the camera is provided to enable un-coupled flash units to be connected to the camera. By separating the flash unit from the camera, special lighting effects are possible.

The flash - integrated into the camera controls

The Canon AE-1 is equipped with a flash contact on the top of the viewfinder prism accepting any flash with hot-shoe contact. But two further contacts apart from the trigger contact show that an electronic connection between camera and flash unit is also possible. The connection is made when a type of flash is used which is specifically designed for the camera and its electronics, a so-called "dedicated flash".

The Speedlite 155A and Winder A were designed for the Canon AE-1.

The Speedlite 155A introduced at the same time as the AE-1 is a small flash unit without adjustable reflector and offers two operating modes, "Auto" and "Manual".

It is interesting that the camera automatically switches to a sync speed of $^1/60$ sec as soon as the flash in the hot shoe is ready. In addition, two working apertures can be preselected at the flash unit which are fed into the camera controls and automatically set on the FD lens whose aperture ring remains in the "A" position during flash operation. Like any other automatically-controlled aperture, the set flash aperture is indicated in the viewfinder display when the unit is ready.

Both the apertures depend on the film speed but the range is fixed - always three metres at the smaller aperture, always six metres at the larger by two stops. Flash exposure, however, is not controlled by the camera as was the case with the Olympus OM2 and later with the Canon T90 and the Canon EOS series. Exposure is computer controlled in the Speedlite 155A flash.

Naturally, manual control is possible according to the guide number but this is mainly used when the flash is operated separately from the camera.

The winder - single shots, multiple shots, not at all - everything is possible

Motorized film transport was not unheard of in the 70's as is shown by the Canon F-1. Small motor drives were used with the Topcon Super DM, a camera almost forgotten now.

Despite this the Canon AE-1 was entering a new area with its Power Winder A. This winder was very small, compact, inexpensive and integrated in the camera control.

To attach Power Winder A to the AE-1 open a small cover in the base of the camera, align the coupling elements and screw the winder into the camera's tripod socket.

The winder is powered by four 1.5V batteries and switched on by its own main switch. If you decide to use the camera without the winder function to avoid its noise, for example, there is no need to disengage the winder from the camera, simply switch it off.

To use the winder for single shots remove your finger from the shutter release immediately. After exposure - no matter how long it takes - the camera orders the winder to wind on the film. That means you are always ready for the next shot without the need to operate the film advance lever and thus alter the image section.

The winder can also be used for multiple exposures. The film is wound on and the shutter cocked after each exposure. The number of times the winder operates per second depends on the exposure time, i.e. the shutter speed. If this is faster than $^1/30$ sec the winder can achieve a maximum transport frequency of 2 fps.

This is useful in several situations. You could separate sequences into single pictures - perhaps a child's first steps. The important thing is to find a suitable combination of large depth of field and fast shutter speed, as a large depth of field compensates to a certain degree for any setting mistakes during refocusing between shots.

If the procedure is repeated several times, more than one picture series can be shot. By mixing the pictures of individual series it might be possible to see more movement phases than can be achieved with winding at 2 fps.

Winder A is fixed to the tripod thread of the Canon AE-1. A clamp holds the covering plate which must be unscrewed from the camera bottom beforehand.

Canon A-1 - the First Multi-automatic Camera

"If you have never seen a single-lens pocket calculator with change-able optics before you had better get used to the idea. Because this is what the new Canon hit boils down to: digital electronics in a SLR from beginning to end." (from a Canon brochure, 1980)

The Canon A-1 followed the Canon AE-1 after two years. It was the top model of the A series and offered so many features never seen in any other camera. Whether this was strictly necessary remains unanswered as good pictures could also be shot with the F-1, the EF and the AE-1. But developments in camera design need to be realized in practice and a great

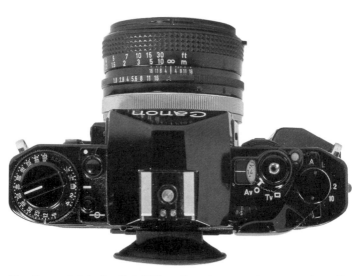

The Canon A-1 is the first SLR multi-mode automatic camera that offers automatic programming as well as aperture and shutter speed priority.

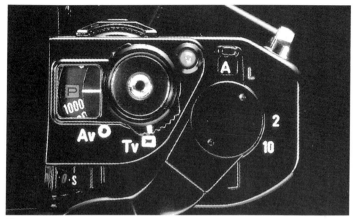

For programmed automatic exposure the AE mode selector is set to the "Tv" position and the AT dial to the "P" position.

choice in options is not necessarily a bad thing. There is no compulsion to use everything on offer.

Exposure control - free choice

Manual exposure

Despite all automatic controls the user of the A-1 can still select aperture and shutter speed for certain lighting conditions and when the desired result can only be achieved by a shutter speed/aperture combination the camera would not choose.

For manual exposure turn the mode selector to "Tv" and select a shutter speed, which can be seen through the AE mode window, by turning the AT dial. Then select an aperture by unlocking and moving the aperture ring of the lens attached.

Any attempt to control the exposure for an average subject by manual setting of aperture and shutter speed is nonsense when the camera offers to do it automatically. Both manual and automatic exposure control rely on the values of the same exposure meter. The camera can convert the result into practice quicker than even an experienced photographer ever could manually.

Programmed automatic exposure

At the other end of options in exposure control there is pro-grammed automatic exposure in the A-1. The mode selector remains in the "Tv" position, but instead of a shutter speed select "P" which is the next setting after $^1/1000$ sec by turning the AT dial. The aperture ring of an FD lens is locked into the automatic position. Now both shutter speed and aperture are controlled by the camera. The exposure meter provides an exposure value according to the subject brightness and the given film speed. Correct exposure is a result of a shutter speed/aperture combination but the central computer of the A-1 cannot simply select any combination. By selecting the programmed exposure mode the exposure value determines the shutter speed/aperture combination which is set by the camera for each situation. With a very light subject (EV 18 relative to ISO 100/21°) the A-1 assumes f/16 (offered by any Canon FD lens) and $^1/1000$ sec (the fastest shutter speed). For each lower exposure value the aperture is opened by a half stop and the shutter speed is increased by a half a step. This adds up to an exposure larger by one stop. When the largest lens aperture is reached the program mode controls only the shutter speed and for every decrease in the exposure value by 1, the exposure time duration is doubled. When the shutter

Set the mode selector to "Av" for aperture priority; a yellow aperture scale then becomes visible. The aperture ring of the lens remains locked into the automatic position.

speed/aperture combinations are no longer sufficient for correct exposure an indicator in the viewfinder warns of under or overexposure.

Many dedicated photographers reject program AE mode on the grounds that the photographer cannot influence the picture, which is nonsense. Even in program mode it is still up to the photographer to find a subject and compose the picture. A well chosen, correctly exposed picture by automatic programming is always preferable to a bland picture tediously arranged manually. Apart from that there are plenty of subjects where picture composition is less important than the ability to shoot quickly and correctly.

Set the selector to "Tv" for shutter priority; a black speed scale then becomes visible. The range of shutter speeds extends from $^{1/}1000$ to 30 sec.

Aperture priority

Aperture priority on the A-1 differed from other cameras, where the aperture was selected on the aperture ring, in that the aperture ring remains in the locked position "A" during aperture priority as well.

The mode selector also controls the aperture. Switch to "Av" and displayed in the AE mode window are the aperture settings we are used to seeing on the aperture ring of the lens. Turn the AT dial to select the correct aperture for the situation. This might be surprising at first but makes sense in the context

When the stop down lever is pressed, the Canon A-1 automatically switches to aperture priority with working aperture metering. This is not recommended for FD lenses unless certain accesories such as bellows without FD coupling are used.

of the Canon system. The decision for aperture priority in the A-1 has the advantage of the FD bayonet being used both for automatic programming and aperture priority. All the transmission elements for aperture control are present with only the shutter speed controls taking place inside the camera.

Aperture priority was still an unknown quantity when the A-1 was introduced but its advantages become clear where the determination of the depth of field was concerned.

Shutter speed priority

Obviously shutter speed priority is also a feature of the Canon A-1. Set the mode selector to "Tv" and all shutter speeds from $^1/1000$ to the full 30 sec are available by turning the AT dial. This is similar to the Canon EF and shows how advanced this

The A-1 is powered by a 6V battery. The small hand grip must be unscrewed from the camera when the battery is changed.

camera was. From this point of view the A-1 regresses a little as the sync speed offered by the A-1 is $^1/60$ sec whereas that of the EF was $^1/125$ sec.

Aperture priority with working aperture

Working aperture metering as offered by the F series of camera is also possible in the Canon A-1 where it is coupled to the aperture priority. As soon as the stop-down lever has been pressed and locked the camera automatically switches over to aperture priority with working aperture metering - irrespective of the setting on the mode selector. In this mode the light falling through the closed down lens aperture is metered and the corresponding shutter speed is set. This is quite convenient when working with uncoupled bellows units and old extension rings although the necessarily darker viewfinder image is less welcome.

The shutter - no power without energy

The electronically-controlled shutter provides accurate exposure at all speeds. But it will not operate without energy. Therefore the A-1 like the AE-1 must be loaded with a 6V silver oxide battery.

The A-1 replaces the backlight control switch of the AE-1 with an exposure memory switch (above) with which difficult lighting conditions can be managed quite easily.

An against-the-light situation where the sun is on the left behind the subject. Slightly less exposure emphasizes the clouds nicely but turns the giant dish into a silhouette. A longer exposure (plus compensation) shows the dish properly but the sky is no longer so impressive. The ideal solution would be to brighten the subject but this is not really possible because of the large scale.

Exposure metering - easily compensated

Exposure metering in the A-1 and the FD lense occurs with wide open aperture. A silicon cell responds quickly and provides reliable results even in low light.

The metering characteristics of the A-1 are similar to the AE-1, i.e. they are centrally integrating and the lower part of the picture is more emphasized than the upper part. In practice this means that a large bright sky in landscape photography will hardly have any influence on the exposure metering.

Despite this, the centre weighted integrating exposure metering still has its limits. Exposure errors with subjects high in contrast are not only unavoidable but they are also to be expected.

The A-1 offers an exposure memory switch. This is situated above the exposure preview switch to the left of the lens. You cannot miss it with your left thumb - but it is almost impossible to activate it inadvertently as it is slightly recessed.

When the exposure memory switch is pressed, the metered exposure value is stored until shutter release. In the case of "P" mode this means that aperture and shutter speed are frozen when the memory switch is pressed. However, if working with aperture or shutter priority, the selection can be changed after it has been stored, because it is the exposure value and not the aperture/shutter speed combination that is stored. Work-

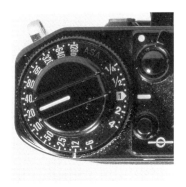

For exposure compensation affecting several pictures the use of compensation factors is recommended. These can be entered via the film speed dial upon releasing a lock. The compensation factors range from +2 to -2 aperture stops given as "4" to "1/4" on the setting dial.

ing with the exposure memory facility is useful for individual shots as well as short series - but when the exposure needs to be corrected for longer series, exposure compensation factors are more suitable.

At the top left of the Canon A-1 is the film speed scale which after pressing an unlocking button also serves as setting dial for the exposure compensation factors.

The A-1's compensation scale is arranged in one-third steps of +2 to -2 exposure stops which should provide the solution for any problem arising in everyday photography. Although the compensation range is limited by the film speed settings of ISO $25/15°$ to ISO $3200/33°$, because of the range of compensation available, extremely fine-grain films such as Kodachrome 25 or Ektar 25 can also be corrected. With each film speed setting one-third of a stop lower, the plus compensation is decreased by one third, and the same goes for higher film speeds and the minus compensation.

If you are really dedicated you could even try to compensate in steps of one-sixth of a stop.

The viewfinder - the pocket calculator look

The alphanumeric viewfinder information - indispensable in modern cameras - was still an innovation when the A-1 came on the market. Although introduced by Fuji with their ST 901, Canon brought this viewfinder display system to perfection with the A-1. It is a combination of letters and figures produced by seven-segment, red LEDs. The standard viewfinder has an image which is clear and easy to see. In the centre there is the usual combination of split image microprism rangefinder, suitable for most subjects. The focusing screen is interchangeable but only by a Canon engineer so the decision to change it must be made carefully.

The screen with split-image indicator but without microprism ring is universally suitable. As most of the focusing is in a direct line to the subject the microprism ring is an extra which is not necessary for many situations.

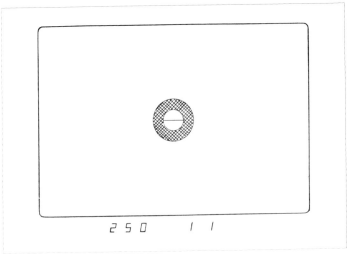

The viewfinder image of the A-1 is very clear. All information is displayed underneath the image where an alphanumeric display is used for the first time.

If you frequently use slow telephotos and tele zooms the screen with a microprism for such lenses could be of interest to you.

The screen with the microprism for wide-open lenses is appropriate for available-light specialists and those who can afford the Canon lens giants.

The matte sectional screen with its grid marking is useful for architectural photography as the camera can be accurately placed for the shot.

The all-matt screen is designed for macro photography with extension rings or bellows.

If working with a microscope or telescope is your main subject area you might find the screen with double cross-hair reticles useful.

All the viewfinder information has been positioned underneath the image. It can be deactivated by a switch on the left of the viewfinder prism.

The type of display depends on the operating mode of the camera.

In aperture priority, shutter priority and program modes the aperture always appears on the right and the shutter speed on the left.

There is no aperture indication when working aperture priority is used as it is manually set on the lens.

When aperture and shutter speed are set manually the chosen shutter speed will be shown in the viewfinder together with the aperture the camera would select for that particular shutter speed. You could take this value as a reference point and select an aperture you prefer. To confirm which mode you are in an "M" is displayed to the far right.

When automatic flash mode is used both aperture and shutter speed are again displayed as well as an "F", provided a suitable flash unit is ready. "M" also indicates that the aperture ring is not in the auto position, if you have set the aperture manually for compensation purposes.

The word "bulb" appears in the viewfinder to indicate that the long exposure setting has been selected.

Not everything will be just the way you want it. Either there is over- or underexposure, or the range of the exposure meter has been exceeded.

In such cases the displays become warning indicators. According to the mode selected the fastest shutter speed and/or the smallest aperture start flashing to warn of impending overexposure and the slowest shutter speed and/or largest aperture flash when pressing the shutter release would lead to underexposure and both displays will flash when the metering range is exceeded.

When something is completely wrong - for example, when you attempt to meter working aperture with an activated motor drive - the information scale shows an error mark (six capital E's).

Flash - even easier

The Canon A-1's flash shoe, like the AE-1, features two additional contact points.

This means that with suitable units flash photography became even more convenient.

The Speedlite 155A, introduced with the AE-1, automatically switches the camera to a sync speed of $^1/60$ sec when the flash is ready. The computer aperture selected on the flash unit is also automatically set on the FD lens whose aperture ring remains locked in the automatic position.

The Speedlite 199A offers the same facilities - although there are three instead of two computer apertures available. Automatic setting of the sync speed can be switched off for fill-in flash and long-term synchronization, or rather be partially switched off. It only operates when a shutter speed faster than $^1/60$ sec has been preselected which would result in partial pictures. Slower shutter speeds are available and are, of course, indicated in the viewfinder.

Motor drive - larger, heavier, faster

The Winder A of the AE-1 can also be attached to the Canon A-1 as the functions are the same as in the smaller camera.

In order to use a winder or motor drive with the A-1 simply remove a small cover from the contacts. The rewind release can be operated from the winder or motor drive.

However, as 2 fps winding is not considered adequate for a top of the range camera like the A-1 Canon offers a special Motor Drive MA for this camera.

The Motor Drive MA consists of a flat plate which is screwed into the tripod socket of the camera and is equipped with a hand grip for ease of use.

Camera and motor drive would make quite a compact unit if the power pack DID not spoil it. There are two kinds, Battery Pack MA and a rechargeable Ni-Cd Pack MA. The battery

There are several ways to depict water by using different shutter speeds. A fast shutter speed suspends the water droplets of the fountain in the air, a slow speed turns the water of another fountain into a curtain from which the golden figure is clearly separated (overleaf).

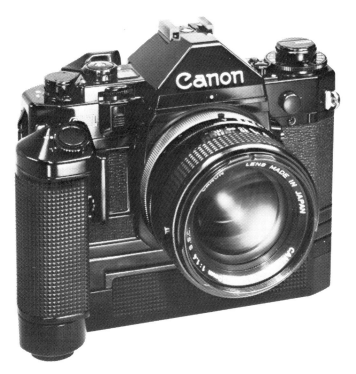

The Motor Drive MA turns the A-1 into a compact and fast motor camera. 4 fps are possible with the NiCd power pack (illustrated). The alternative battery pack even offers 5 fps.

pack holds twelve 1.5-V AA batteries and is therefore rather heavy. But this unit has the advantage over the rechargeable power pack in that the output is higher - 5 fps in the H setting and 3.5 fps in the L setting. On the other hand the rechargeable Ni-Cd Pack MA is lighter but its output is 4 fps in H and 3 fps in L setting.

The motor drive has its own shutter release button situated in the hand grip. A second shutter release button can be found on either of the two power packs. These shutter release buttons come in very useful when photographing in the vertical position.

When the Speedlite 199A is used exposure series can be made with motor and flash. Over short distances and with a high speed film such as Kodacolor Gold 400 or T-Max 400 you could even shoot 5 fps with flash.

The winder or motor drive becomes important when wireless remote control units or the Canon Infrared LC-1 are used. The shutter can be released from a distance of 50 or 60 metres. This is convenient when shooting wildlife, for example, when the presence of the photographer would frighten the animals away.

Equipment - a lot inside and out

The shutter release...

...is a electromagnetic two stop release. Pressing the button down to the first stop activates exposure metering, automatics and indicators. When the release button is pressed right down exposure occurs and any other functions are activated, i.e. the aperture is closed, the shutter is released, an attached flash fires and a motor drive winds on the film and recocks the shutter after exposure. Both these stops can be felt quite distinctly.

The shutter release features a threaded socket for a cable release.

The main switch...

...interrupts the power supply to the camera unlike the F series cameras where this feature locks the shutter release mechanically.

When this switch, which revolves around the axis of the film advance lever, is pushed backwards it becomes the...

Self-timer release...

...which can be locked into two positions. In position 2 the electronically controlled running time is two seconds which is useful instead of a cable release, and correspondingly the 10 sets a ten-second time lapse before exposure if you want to

include yourself in the picture. The self-timer sequence is indicated by a...

red LED signal...
...which flashes slowly at first then faster during the last two seconds. The LED also flashes when...

the battery check button...
...located to the left of the viewfinder prism is pressed indicating that there is enough power left in the 6V battery. As the battery runs down the LED signal becomes weaker and when it is very slow it is time to insert a new battery.

The self-timer can be set to 2 (illustrated) or 10 seconds delay.

The multiple exposure lever on the right of the top plate is almost obscured by the film advance lever. When activated the film winding mechanism is uncoupled. Film advance lever and motor drive only operate the shutter release and cock it while the film remains in position. This can be checked on the...

frame counter...
...only visible when the film advance lever is standing off from the camera body. It counts forward when the film is advanced and backwards when the film is rewound into the cassette. It remains stationary when you want to make multiple exposures. These are only possible in conjunction with a motor drive as without this accessory only double exposures can be made. Operating the film advance lever returns the multiple exposure lever to its starting position.

The flash socket enables the A-1 to be connected to flash units with sync cable. This feature is especially important for wireless flash units. Studio flash units can also be operated by the A-1.

The eyepiece shutter lever...

...is located to the left of the eyepiece which must be protected from incoming light when the camera is on a tripod and the photographer is not looking through it. Any light coming from behind could alter the meter readings.

The PC socket...

...on the front left of the camera is provided for cables of uncoupled flash units to be connected to the camera. By separating the flash unit from the camera special lighting effects are possible, particularly in studio situations. Small studio flash units can also be used by the amateur who is especially interested in portrait, still life or tabletop photography.

The exposure preview switch...

...underneath the exposure memory switch allows the exposure meter to be activated with the left hand. You can read off the values in the viewfinder information panel and make any alterations to aperture or shutter priority with your right hand.

The stop-down lever...

...is used for exposures with working aperture or for finding out about the depth of field. Unfortunately on the A-1 the lens cannot be stopped down with this lever without turning the

aperture ring from the automatic position. First you need to find out which aperture needs to be set by checking the viewfinder, then the aperture ring must be unlocked, the desired aperture set, the stop-down lever pressed before looking into the viewfinder again.

If you are good at judging distances you should dispense with such a complicated procedure and look instead at the depth of field scale on the lens.

When pushed upwards the AT dial guard prevents the AT dial being altered inadvertently.

The AT dial guard...

...prevents inadvertent alteration of this dial. The use of this feature is specially recommended when working with programmed exposure.

The "bulb" setting...

...is naturally featured in the A-1 as well. Set the selector dial to "Tv" and turn the AT dial until "b" for bulb is displayed in the AE mode window. Varying exposure times can be controlled with a lockable cable release - even if it takes hours, for example, in astro photography.

The camera back...

...is easily removable and can be exchanged for a data back. The three setting dials serve to imprint certain data on the film, e.g. the date, or an alphabetical or numerical code. A useful feature for scientific work or to record your children as they grow up.

The program AE is a great help in capturing a good subject. The centre-weighted metering has no problems here.

Canon AE-1 Program - a Little of Everything

"Despite its familiar name the AE-1 Program is completely new and even more sophisticated than the original AE-1." (From a Canon brochure, 1983)

The exterior of the Canon AE-1 Program clearly indicates its position in the Canon range of cameras: between the A-1 and the AE-1. Similarities can been found with both these cameras and it is difficult for the photographer to assess its true character: as an independent camera.

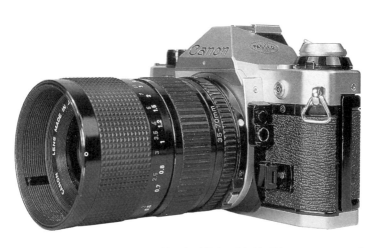

The Canon AE-1 Program resembles the AE-1 and A-1 both in appearance and technology, but it is a separate model in its own right.

The viewfinder - a string of lights

The Canon AE-1 Program features an uninterrupted viewfinder image with only the new split-image microprism rangefinder visible in the centre of the standard focusing screen.

The new split rangefinder eliminates the curse of older split-image rangefinders as it avoids darkening the image when slow lenses are used and even blacking it out completely at f/4. Slower zoom lenses also present no focusing problem. The focusing screen, too, is new. Its surface has been laser treated giving a brighter and more uniform image than the screen of older cameras.

All the necessary exposure information apart from the shutter speed is displayed on the right-hand side of the viewfinder image. The apertures range from f/1 to f/32. It is doubtful whether the "1" is a pointer to the planning of one of the giant lenses of the future such as the EF 1/150 as the camera's FD bayonet would have presented too many problems for that. But FD lenses of f/1.2, which were around at the time of the AE-1 Program could be accommodated. The type of display in the AE-1 Program is somewhere between the analog display of the AE-1 with a meter needle and the digital display of the A-1.

The aperture display of the AE-1 Program consists of eleven settings, one below the next. The aperture selected is illuminated and you can either read off the value or judge the size of the aperture by its position on the scale.

Above the aperture scale is an "M" on a red background and a "P" on a green one. "M" indicates that the aperture ring is not in the automatic setting and the "P" that the shutter speed selector dial has been turned to program mode. The "P" also warns of camera shake when the shutter speed selected is $^1/30$ sec or slower.

Below the aperture scale is a flash symbol indicating that the flash is charged and correct flash exposure will occur according to the type of flash used.

Naturally the display also indicates impending under and overexposure by flashing either the smallest or the largest aperture.

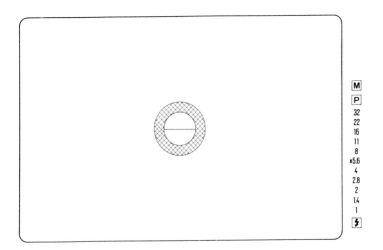

The viewfinder of the AE-1 Program is very clear. The exposure values are shown on the right by LED numbers. The panel also indicates when the flash is ready and - in the case of suitable flash units such as the Speedlite 188A - the correct flash exposure.

Exposure metering - centre-weighted and versatile

Open aperture metering introduced with the Canon F-1 and FTb together with the FD lenses is featured by the AE-1 Program as a matter of course. Although working aperture metering is not usual any more it is still possible. It should only be selected, however, when really necessary, e.g when un-coupled accessories are used.

The centre-weighted metering characteristic of the AE-1 and A-1 is also evident in the AE-1 Program. Emphasis is made of the centre of the picture reducing any undue influence from a bright sky at the top of the picture.

Like the Canon A-1, the AE-1 Program also features an AE lock switch (above). Simply touch it lightly to store the metered value until shutter release.

Exposure compensation - quick and safe

When shooting with wide-angle lenses and the immense sky above the landscape is desirable, the bright sky will influence the exposure despite the centre-weighted averaging system. If you want to avoid the landscape being too dark keep the camera in the position for the right image and first press the shutter release lightly. Now the exposure meter, exposure control and the indicators are activated and you can find out which aperture the camera intends to use. Point the camera downwards keeping the shutter pressed half-way down. In the aperture display you can now observe how the camera indicates an ever-increasing aperture. When the landscape fills the viewfinder image you can see by how many aperture stops the landscape is underexposed when exposure is evaluated by the sky.

Calculate how much you want the landscape under exposed and the sky overexposed for the desired picture. Move the camera up again and when a suitable aperture for both the landscape and the sky is displayed press the AE lock switch to the right of the lens mounting. This only needs to be pressed very briefly in order to free you again for refocusing if necessary. The metered value is now stored and will be used as soon as the picture has been composed and the shot is made. When the difference between bright sky and dark landscape is too great it is preferable to meter for the sky and put up with the

landscape being too dark as an overexposed sky never looks good in the picture. Another option would be to use a grey graduated filter.

Compensation values cannot be preselected to influence the result of the exposure meter. It is, of course, possible to use the film speed setting for that purpose. The film speed settings

The film speed scale is hidden underneath a ring surrounding the rewind crank. The lock release button must be pressed to enter a new value.

range from ISO 12/12° to ISO 3200/36° and the value can be selected in steps of three. Which means that exposure compensation also occurs in steps of three. If on the other hand you have adjusted the film to your own requirements and always expose with a different film speed setting, exposure compensation must be calculated from that value, which might lead to mathematical problems.

Calibrating the film - colour as required

Calibrating a film means this. Each film reproduces colour in a certain way. Slight over or underexposure influences the colour somewhat, either towards paler or stronger shades, which you might prefer.

If you have a favourite film and want to find out how the colours are reproduced, with slight under- or overexposure, take a few trial shots. For the first picture of each series set the speed given for the film loaded. Then take three pictures at a

film speed setting each one at a third lower than the last and then take three more pictures increasing the speed by a third each time. Using Ektachrome 100, say, with all film speed settings from ISO 50/18° to ISO 200/24° exposed, you can then decide whether you want to expose it as ISO 125/22° from now on or whether you prefer ISO 80/20⁰ after all. Five such exposure series can be made with a 36-frame film with five subjects under differing lighting conditions and with different colours. Try to avoid including very tanned subjects on at least one of the series in order to be able to judge a correct skin colour.

Programmed exposure - very versatile

The advantages and disadvantages of programmed exposure are discussed energetically just as much as the pros and cons of shutter speed priority versus aperture priority used to be debated.

The disadvantages are clear; as the camera automatically selects a shutter speed and aperture according to the lighting conditions and the film speed, the photographer has no influence on the representation of movement or the depth of field.

But the advantages are equally obvious; if you are not sure which shutter speed and aperture to select, simply chose the "P" setting. It allows correctly-exposed pictures to be taken

The shutter speed dial also serves as the mode selector. In the "Program" position the camera determines aperture and shutter speed. The selector dial is not locked in this position but cannot easily be moved inadvertently.

Programmed exposure is ideal for snapshots - like these two small children looking down from their parents' shoulders.

without great technical knowledge. It is also a useful mode for simple snapshots. It is unlikely that you can judge from "child in the sandpit" whether it was shot with a meticulously chosen shutter speed and aperture or whether programmed exposure was used.

Automatic exposure on the AE-1 Program is designed to adjust aperture and shutter speed to a lower light value by half a stop each when $^1/1000$ sec and aperture f/16 have been selected. The shutter speed/aperture combinations always remain the same and it might be worth while to learn them in order to be able to find out which shutter speed the camera selects by looking at the aperture display in the viewfinder. This display only shows whole aperture stops, however, although it would have been a simple operation to indicate intermediate stops by illuminating two aperture values. When the aperture cannot be opened any further the programmed

mode only controls the shutter speed until the limits of the metering area are reached.

The individual shutter speed/aperture combinations of the programmed exposure mode are as follows:

1/1000 sec and f/16
1/500 sec and f/11
1/250 sec and f/8
1/125 sec and f/5.6
1/60 sec and f/4
1/30 sec and f/2.8
1/15 sec and f/2
1/8 sec and f/1.4

These are always two aperture stops apart. In addition there are the intermediate values such as 1/750 sec and aperture f/13 which are not displayed in the viewfinder.

The table above applies to all films - from a slow Kodachrome 25 to a very fast T.Max 1000 - only the brightness for the individual combinations alters.

Obviously the widest opening of a lens is the limit to which the aperture can be opened. The aperture values f/2.8, f/2 and f/1.4 must be changed to f/4 when a lens with a maximum aperture of f/4 is used.

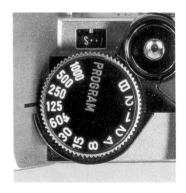

The AE-1 Program features shutter speed priority when the aperture ring of the lens is locked in the "A" position. The shutter speeds range from 1/1000 to 2 sec.

The LED panel inside the viewfinder informs the photographer which aperture has been selected automatically. By choosing a suitable shutter speed he can quickly reset an aperture offering the desired depth of field.

If you want to make use of automatic programming on the AE-1 Program you should turn the shutter speed selector dial to the "P" position and the aperture ring of the lens to "A".

Shutter speed priority - according to Canon tradition

The Canon AE-1 Program also offers shutter speed priority. The shutter speeds are set on the large selector dial which has a protective guard behind it to prevent the setting being altered inadvertently by operating the film advance lever.

Available shutter speed settings on the AE-1 Program range from 2 to $^1/1000$ sec, making it a camera not exceptionable from that point of view.

The advantages of shutter speed priority are well known - prevention of camera shake blur and the representation of movement, by either blurring through slow shutter speeds or freezing with fast shutter speeds.

Both effects - blurring and freezing - can be combined. Interesting results are particularly good in sports photography and action shots. The movement of running children or animals can be tracked by first selecting a medium shutter speed and focusing on a certain point your subject is going to pass. Then

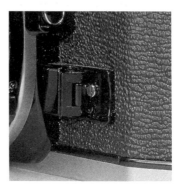

Once a suitable aperture has been set on the aperture ring of the lens, the depth of focus in the image can be checked by pressing the stop-down lever.

point the camera at the distant subject and pan the camera trying to keep the subject centrally in the viewfinder. The focusing aids are obviously useful here. When the subject has reached the specified point you release the shutter - without stopping the movement of the camera. The result is a picture where the subject is sharp or at least quite sharp before a blurred background.

If you want to set a certain aperture for a specific depth of field operate the exposure preview switch located underneath the AE lock switch to the left of the lens mount. This activates the exposure metering and control. At the same time turn the shutter speed selector dial with your right hand until you see the desired aperture in the viewfinder. When this value is set manually on the aperture ring of the lens the aperture can be closed by using the stop-down lever and you can see in the viewfinder how the depth of field embraces the subject.

This procedure can also be reversed. Unlock the aperture ring, operate the stop-down lever, return the aperture ring to the "A" mark and select the shutter speed leading to the established aperture.

The temptation to meter the exposure with the stopped down FD lens is great, of course, but you should resist it as exposure errors can be expected.

The equipment - all the necessary things are provided

The shutter release...

...of the AE-1 Program, like the other two cameras mentioned in the A-series, consists of an electro-magnetic two step release with a threaded socket to accommodate a cable release.

When a motor drive is used with the AE-1 Program, interval shots can be made with the help of a lockable cable release and the self-timer. The self-timer is activated and the cable release is pressed and locked - there are several kinds available from Hama. Pressing the cable release not only starts the shutter process but also the running of the self-timer. After ten seconds the picture is exposed. An attached motor drive immediately prepares the camera for the next shot. In this way a 36-frame film can be exposed in about six minutes.

Although there are not many subjects suitable for interval photography, when the camera is set on a tripod and aimed at a baby sitting in his high chair, putting things in his mouth and throwing others on the floor, a six-minute picture series can be quite funny. Make sure that the motor drive MA and winder A2 are not set to individual shots as the fixed cable release will have no effect in this case.

The main switch...

...on the right of the camera top plate can be set to "L" to lock the shutter release which is advisable when the camera is not in use as the shutter release itself reacts to the slightest touch and could inadvertently be activated. The main switch also controls...

The main switch of the AE-1 Program. In the "L" position the power is disconnected, preventing inadvertent shutter release. When the lever is moved to the "S" position the shutter release is delayed by 10 seconds.

The self-timer...

...when turned to the "S" position, delaying exposure by ten seconds. The self-timer sequence is indicated by an audible signal which cannot be switched off.

The hot shoe...

...on the top of the camera, apart from the hot contact in the centre, also features two other contacts. Via these contacts, suitably equipped flash units - primarily those of the Canon Speedlites A series - effect the automatic switch-over to the

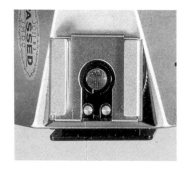

Apart from the contact in the centre, the hot shoe features two further contacts which automatically switch over to the sync speed and the computer aperture selected by the flash unit as well as causing the correct flash exposure to be displayed.

sync speed, which in the case of the AE-1 Program is $^1/60$ sec. In addition the computer aperture selected by the flash unit is automatically passed to the lens and the flash-ready symbol in the viewfinder lights up at the right moment.

In combination with the Speedlite 188A the AE-1 Program also informs you that there is sufficient light from the flash for correct exposure. The light reflected from the flash is registered by a sensor inside the flash unit. For flash units without hot shoe connection there is...

The power connection socket...
...at the top left on the camera front. The large Speedlite flash units have no use for this socket as they can be used in the hot shoe with a suitable adapter. SCA flash units or perhaps the Vivitar 283 also offer this feature, the latter without automatic switch-over of the sync speed and with manual aperture selection.

The ISO film speed setting lever...
...is located on the left of the viewfinder and is well hidden. It can be found underneath a smooth ring surrounding the film rewind crank. A window in the ring shows the ISO film speed setting. The setting can be altered by pressing the lock release button and turning the small lever.

The battery check button is large and prominent. It can also be used to interrupt the self-timer sequence to prevent an exposure.

The battery check button lies between the viewfinder and the film rewind crank on the top of the camera. An audible signal indicates that the 6V battery is sufficiently charged. When the signal frequency decreases the battery is running down and it is a good idea to keep a spare. The battery check button can also be used to interrupt the self-timer sequence.

The back cover...

...of the Canon AE-1 Program can be removed easily and exchanged for a data back to facilitate the imprinting of the date or other data.

The back cover of the AE-1 Program can easily be removed. The data back can be used to insert dates and codes into the picture.

There is no need to show the whole subject. It is often sufficient to fill the frame with only part of it. Strong colours add interest to such pictures (opposite and overleaf).

The "bulb" setting...

...is also a feature of the AE-1 Program. Set the shutter speed selector to the position "B" and operate the shutter release. Automatic exposure control and metering are inactive and the aperture ring must be set manually to the required value.

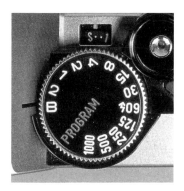

Long exposure times can be controlled with the B setting, which requires a cable release.

The B setting is useful for photographing fireworks, for example. Take an aperture of f/11 with an ISO 100/21° film as a base. Open or close this aperture appropriately if the

actual film loaded is slower or faster than ISO 100. Leave the shutter open until some of the fireworks have been discharged into that part of the night sky which is within the angle of view of the attached lens, which obviously should be a wide-angle if you are anywhere near the launching area of the rockets. Across greater distances a zoom is useful as you can determine the image section precisely after you have found the area in the sky where the first fireworks have exploded.

The motorized AE-1 Program - extending the facilities

When the AE-1 Program came on the market Canon also introduced a new motor drive - Power Winder A2. Now there are three options for winding on the film automatically with the Canon A-1 and AE-1 Program. Motor drive MA can be used,

although even with the battery pack it can only wind on 4 fps, as opposed to 5 fps with the A-1 camera. Winders A2 and A can also be used.

Winder A2 is not much different from Winder A, advancing the same number of fps (2), but it is better equipped. There is a switch to convert from single shot (S) to continuous (C) wind and also a connector for remote control release devices such as the Infrared LC-1.

Interchangeable focusing screens - do it yourself

There are eight different focusing screens available for the AE-1 Program, six of which correspond to those of the A-1. These are new split-image microprism (built in as standard), micro-prism, new split, all matt, matt/section, double cross-hair reticle, matt/scale and the cross split-image. If you get the opportunity choose the cross split-image screen as a focusing aid because it sections the image not only vertically but horizontally, making focusing quicker and easier.

FD Lenses - Grab them While you Can

Sophisticated a camera may be, in the end it is the lens that determines the picture. This is born out by the importance of Canon's FD and FL lenses. Today there are almost 40 high-quality lenses in the range... Originally designed for the F-1 system these lenses undoubtedly are world champions; their performance is orientated on professional standards." (From a Canon brochure, 1978)

At the beginning of the 80's the Canon FD lens system was one of the most extensive range on the market. The catalogues offered many more than those 40 lenses praised in 1978. When the development of manually focused cameras reached its zenith with the Canon T90 there were nearly 60 different lenses available.

By the time the EOS system of autofocus SLR cameras and the autofocus lenses with EF bayonet came on the market, the range of FD lenses started to get smaller and with the introduction of the Canon T60 as a starter model for SLR photography in 1990 the situation of 1978, with 40 lenses, was once again reached. But there is one major difference; today there are many more of the FD lenses, no longer officially featured in the product lists, available second-hand from photographic dealers and via advertisements in the photographic press. Apart from that there are also a number of new and used other lenses available featuring an FD bayonet.

The FD bayonet - solid and indestructible

Most FL lenses, which made up the Canon lens system before the introduction of the Canon F-1, can be used with all Canon SLR cameras right up to the A-1, and even the T70 and T90,

although there is always the restriction of the working aperture metering.

FL lenses are equipped for open aperture metering, i.e. the aperture can be set on the aperture ring without closing the aperture leaves. These only close when the stop-down lever is pressed or the shutter is released. Afterwards the aperture opens again and the viewfinder image is as bright as the focal length of the lens permits.

FD lenses also feature spring apertures. But they also have an aperture simulator and an input pin feeding the focal length of the lens into the camera. The aperture simulator transfers the value of the preselected aperture into the camera. The metering achieved with wide open aperture can thus be converted to the preselected aperture.

There is no mechanical difference between the FL and FD lenses of the first generation. The central part of the Canon bayonet is the revolving chromium plated ring.

A Canon lens is always attached to the camera at a right angle. When the lens is pressed against the camera the chromium ring revolves a little, just enough to link the lens safely to the camera. Then the lens is secured by a slight turn. Apart from the chromium plated ring nothing else moves so nothing can be worn out by frequent use.

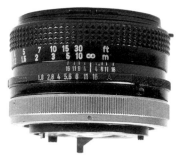

For a long time the chromium ring was an unmistakable characteristic of the Canon FD lenses. It moves slightly when the lens is inserted into the bayonet of the camera.

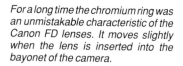

138

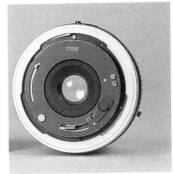

The Canon F-1 camera and FD lenses opened the way to exposure metering with wide open aperture. This is made possible by the aperture simulator (here in the lens bayonet on the left).

The bayonet was changed in 1979 in that the chromium plated ring was removed and its function was taken over by the outer covering of the lens. The FD lenses of the second generation are not linked to the camera merely by pressing against it, however. Now there is a locking button which has to click into place before the lens is securely attached to the camera and it must be pressed to remove the lens.

Another difference between the FD lenses of the early days and those after 1979 is that plastic was introduced into the construction of lens barrels and the lenses became smaller and lighter without losing anything in performance.

One important point that applies to all FD lenses is that the stop-down lever of the camera must not be pressed when the lens is attached, otherwise a red dot indicates that the spring aperture lever in the mirror box of the camera is in the wrong position.

The chromium ring has disappeared with the FD lenses of the second generation. The plastic body is black throughout. The transfer elements of these lenses don't move when they are attached to the camera.

Lens cap - avoid the dirt

One more important point in connection with a lens change is that it is imperative the front and back surfaces are not masked or scratched in order to retain a high-quality lens Replace the caps immediately after detaching the lens from the camera.

Lens hoods and coating - protection against flare

A lens hood, often called sun shade, can also be regarded as protection for the front lens. The prime function of the hood, however, is to deflect any stray light from the lens which might diminish the picture quality.

The imaging performance of coated lenses can also be impaired by stray light. Lens coating is a familiar feature today but in the early 70's when Canon started to coat the lens surfaces, to prevent stray light or reflections, it was still thought necessary to advertise this procedure by making it part of the lens name, such as letters like "S.C." or "S.S.C.".

Which lens when? - Fixed focal length

The Canon reflex catalogue of 1974 features 31 lenses - only three of them zooms. Those variable focal length lenses were not very popular. The situation has changed somewhat today.

The reason for the lack of popularity of zoom lenses at the time was that the lens manufacturers did not have the technology to build really good zooms. Although excellent zoom lenses can be built today, Canon's FD system was designed with the professional photographer in mind who demanded very fast lenses and/or lenses with extreme focal lengths. Both are areas where high quality zooms are already represented but which are dominated by fixed focal lengths.

In the areas of normal apertures and focal lengths there are still reasons to go for a fixed focal length. Although a zoom can be used very effectively, a fixed focal length has the edge when it comes to resolution and contrast from the centre towards the edges and corners of the picture.

Which lens when? - Zooms

The characteristics of zoom lenses are their variable focal lengths.

Just a brief movement of the hand changes the focal length from short to long, i.e. to go from a wide-angle to a telephoto and a medium tele to a long focus lens. Being able to alter the focal length quickly can save many a snapshot. And it also resolves the problem of a heavy camera case with too many different lenses. Sometimes it only needs a slight finger movement to alter the focal length by a few millimetres. Although it will not turn a wide-angle into a telephoto it could improve a tele shot by filling the frame. If you frequently use Ektachrome 100 or Kodachrome 200 slide film you will soon not want to miss being able to select precisely your desired framing. A zoom lens is perhaps not as important when negative films are developed and enlarged at home where the desired framing can be selected afterwards.

Zoom lenses are usually slower than fixed focal length lenses - this can be compensated for, however, by using faster films or a tripod.

There are two different types of zoom available; zooms where the focal length is selected by turning a ring and focused by turning another ring. The other type is a sliding zoom which is focused by turning the setting ring and where the focal length is altered by sliding the ring forwards or backwards.

Two-touch zooms are slightly more complicated to handle but once focused the setting remains during the zooming operation. When the focal length is changed on a sliding zoom the focus could inadvertently be altered as well. To avoid mis-understandings; from the design point of view the focus remains the same in zoom lenses unlike in variable focus lenses.

When two zooms form part of the equipment - perhaps a wide-angle and a telephoto - and are possibly used on two separate bodies it might be a good idea to chose both lenses from the same group to avoid any problems when changing the lenses.

Which lens when? - Normal focal length

The standard lenses for F and A series SLRs generally were normal lenses such as the FD 50mm,f/1.8 and occasionally the FD 50mm,f/1.4, faster by just under one stop but rather more expensive. The normal zoom with a focal length of 35-70mm or even 28-70mm had not yet achieved great popularity.

Normal lenses were assumed to be inadequate for proper photography. But really the normal lens is a very good all-rounder which can be used in many different subject areas.

The normal lens of a compact camera has a focal length of about 40mm corresponding to the diagonal of the film format.

Its advantage is that the image angle of a 40mm lens depicts only marginally less than can be seen with the naked eye avoiding the steep perspectives of the wide-angle or the flat perspectives of telephoto lenses.

Canon zooms FD 35-70mm, f/4 and FD 75-150mm, f/4.5 make an ideal small lens outfit offering great performance. The wide angle to normal zoom is a two-touch lens, which is focused by turning a ring, whereas the tele zoom is a one-touch lens.

Another big advantage is that the photographer using a normal lens is obliged to approach the subject more closely in order to achieve a reasonably large image. Obviously there are subjects better avoided from very close up - a wild lion, say, or an interesting rock in a roaring mountain river - but generally speaking, the closer, the better the picture.

The normal lens is also quite small, light and sufficiently fast.

Which lens when? - Wide-angle lenses

All lenses with a focal length shorter than the normal lens are generally called wide-angle lenses. Lenses with shorter focal lengths than about 24mm are categorized as super wide-angle lenses and fish-eye lenses have even shorter focal lengths.

35mm lenses...
...were regarded as wide-angle lenses for a long time. When many compact cameras started to feature 35mm lenses as standard this lens somewhat lost its exotic wide-angle status. We have accustomed ourselves to the image angle of that lens since it approaches the perception we get with the naked eye nearer than that of a 50mm normal lens.

There are a number of excellent 35mm lenses in the Canon system. For example, the FD 35mm,f/2, in its S.S.C. version is still very popular. But a zoom such as the FD 35-70mm,f/4, which was part of the first FD lenses of the second generation to come on the market, is eminently suitable as a wide-angle.

Like the 50mm lenses the 35mm lenses can be used for most subject areas. They offer the photographer of architecture the opportunity to stay further away from a building which avoids converging verticals to a certain extent. Group pictures can be taken well with this lens and because of the large depth of field focusing is not always necessary when taking snapshots. Other subject areas where the 35mm lens can be used include landscape, panoramas, interiors and interiors with flash as most flash units will illuminate the image angle of a 35mm lens without additional accessories.

28mm lenses...

...have more or less replaced the 35mm lens as general purpose wide-angles. The angle of view of a 28mm lens is 74^0 which is suitable whenever large subjects need to be covered from a short distance, when you want to create an overview and when you want to give the impression of great depth.

Unlike the 35mm, the 28mm lens is less suitable for group pictures or snapshots. Either you stand back from the subject and all the people come out very small in the picture or you go closer to the subject resulting perhaps in blurred people at the edge of the picture.

There was always an FD 28mm,f/2, and FD 28mm,f/2.8, lens in the Canon system but over the years this was extended to include zooms such as the FD 28-85mm,f/4. The FD 20-35mm,f/3.5, L too, covers the 28mm focal length but this lens is for the connoisseur as it is not cheap.

28mm lenses have tended to replace the 35mm lenses as universal wide-angle lenses. They are very suitable for interior or landscape shots as the steep perspective of wide angles is not very evident at this focal length.

24mm lenses...

...are placed somewhere between wide-angle and super wide-angle lenses. They have an angle of view of 84^0 which can be problematic in some situations. In landscape photography the sky is often depicted too large and sometimes including the sun in the picture is unavoidable. Although architectural pictures can be shot from short distances the converging verticals are often too prominent while from greater distances the foreground can be emphasized too much, destroying the composition.

Every good outfit should include a 24mm lens. It offers exciting overall views, enables you to shoot in cramped conditions, and even offers a large depth of field with the larger apertures.

Despite these problems the 24mm lens is a good addition to your equipment. Grand overall views are possible, it creates depth to the picture by its steep perspective and allows surprising effects in portraiture.

Among Canon's 24mm lenses the FD 24mm,f/1.4 L is rather special but the normal FD 24mm,f/2.8 is quite a good lens, too.

The foreground inevitably included by the large image angle of a super wide-angle lens can be rather dull. Here the reflection of the clouds in the water has livened up the picture.

Which lens when? - Super wide-angles

Lenses of focal lengths shorter than 24mm clearly belong to the super wide-angle range. In the Canon system these lenses are represented by the 20mm, 17mm and also 14mm versions, of which the FD 20mm,f/2.8 and the FD 17mm,f/4 come with or without a chromium plated ring and where the FD 14mm, f/2.8 L is quite expensive but nonetheless very desirable, reducing any distortion to a minimum.

The 17mm lens is a must for large scale photography. If you cannot handle large image angles don't buy it. The viewfinder image must be checked for distracting features in the foreground. In landscapes, exposure compensation is frequently necessary due to the large amount of sky included in the image.

Areas of application for these lenses are landscapes, large interiors like churches etc. where the use of a tripod and a small spirit level for the flash hot shoe is recommended. The FD 20-35mm,f/3.5 also needs to be mentioned in this context as this lens is the ultimate where large image angles are of great importance.

Which lens when? - Fish-eyes

There are two lenses in the Canon system which quite deliberately avoid correcting any distortion. The FD 15mm,f/2.8 and FE 7.5mm,f/5.6 - which incidentally features no FD connection and is used in conjunction with open aperture metering or a separate exposure meter - distort the image barrel-fashion, i.e. all straight lines not running through the centre of the picture are curved towards the edge.

Fisheye lenses such as the FE 7.5mm,f/5.6 show anything that is in front of the domed front element. The 7.5mm lens possesses none of the FD characteristics.

By accepting these distortions you can achieve an image angle of 180°. In the 15mm lens, a full format fish-eye, this effect is only evident in the picture diagonal whereas the 7.5mm lens is a circular fish-eye with an image angle of 180° all round which includes everything from the edge of the front lens - even the photographer's feet or the tripod!

Fish-eyes are speciality lenses designed for monitoring tasks and not often used in amateur photography. Almost every subject is suitable for a fish-eye - although the barrel distortion is not necessarily a guarantee of a clever picture. But narrow

interiors, landscapes under a large overcast sky, abstract rock formations or cars shot from a worm's eye view present novel ways when shot with a fish-eye lens.

Which lens when? - Telephoto lenses

Telephotos are lenses with a focal length longer than 50mm. They can be categorized into different groups of portrait tele- photo with focal lengths from 70mm to 135mm, long telepho- tos with focal lengths up to 300mm and the special super telephotos.

Portrait lenses...

...feature focal lengths of 85mm to 105mm making them very suitable for head and shoulder or half length portraits. The distance to the subject is not too short to be intrusive but is not long enough to give a flat perspective. In addition the depth of field with wide open aperture is still narrow enough to sepa- rate the subject clearly from a blurred background. These lenses can also be used in landscape and nature photography as they can emphasize detail very well.

A good representative of this group is the FD 85mm,f/1.8 available with or without chromium ring. The FD 100mm,f/2 is also a good short telephoto.

FD 100mm,f/2 and other short telephotos, classified as portrait lenses, can also be used for other purposes. Because of the small depth of field a sharply rendered main subject can be separated quite well from a blurred background over small distances with wide open aperture.

A zoom covering the medium focal lengths is used to fill the frame with the peacock without getting too close.

135mm lenses are almost too long for portraits but not entirely unsuitable. The FD 135mm,f/2, is appropriate for snapshots or reportage pictures as it can be used from a middle distance resulting in frame-filling pictures. The tight image angle cuts off interfering surrounds and with a wide open aperture the narrow depth of field separates the subject clearly from the background.

The FD 70-150mm,f/4.5 is a very good lens for these applications. But zooms linking the short tele range to the wide-angle range such as the FD 28-85mm,f/4 or the FD 35-105mm,f/3.5-4.5 are also worth considering. Overall views and details are separated only by a turn of the focal length ring.

Focal lengths from 200mm to 300mm are not only suitable to get a close-up of subjects that are a long distance away - a castle on top of a hill from down in the valley, for example - but lenses such as the FD 80-200mm,f/2.8, FD 300mm,f/5.6 or even the zooms FD 80-200mm,f/2.8 and FD 100-300mm,f/5.6, can also be used to show small subjects quite large.

Lenses with long focal lengths are widely used for sports, animal and journalistic photography although they can also be used wherever the subject needs to be condensed optically (e.g. cars in a car park).

Which lens when? - Super tele lenses

The long focal lengths of 400mm to 1200mm are specialized lenses rarely used in everyday photography. Heavyweights such as the FD 800mm,f/5.6 L (around 4400g) are indispensable for action photography, however, where you want to capture the activities in the centre of the football field from the stands. The contest between two footballers or the concentration of a baseball bowler can only be caught with such a lens. They are also useful when on safari where the distant mountain range can be brought closer or the sun can be shown as a gigantic fireball above the plains.

But for normal use these special lenses are too large, too heavy and too expensive.

Powerful lenses, such as the FD 400mm,f/2.8 L, are really only for the specialist as they are expensive and heavy . Otherwise a good 200mm lens with a converter, or a less powerful Sigma 400mm,f/5.6 lens would be adequate.

Conventional portrait lenses are not necessarily recommended for a portrait of a dromedary. A 300mm lens would provide a more convenient shooting distance.

Which lens when? - The specialists

There are some lenses in the Canon system specifically designed for certain tasks. That does not mean they cannot be used like other lenses of the same focal length. But as their specialist status is reflected in the price you should only consider adding them to your equipment if you know you will make good use of them.

Macro lenses...
...increase the range of application until just in front of the subject which is shown very large. These lenses have an image/object ratio from 1:2 (half life size) to 1:1 (life size) and perform especially well in close-up situations. A good lens is the FD 200mm,f/4 Macro, which can be used both as a telephoto and as a macro lens and which because of its long focal length allows convenient shooting distances.

Architectural pictures need not always show the entire facade. Details can be very picturesque when captured with a long focal length lens.

Whenever you want to fill the frame with small subjects you need a macro lens. These lenses are designed to perform well at close range and large reproduction ratios. The FD 100mm,f/4 Macro shows the subject half-life size, or life sized when combined with an adapter.

The TS 35mm,f/2.8 shift lens...

...is a lens which cannot be used with open aperture metering because of the flexibility of the lens which can be moved up or down, sidewards and also tilted against the optical axis.

This flexibility allows you, in architectural photography, to take in the entire building without having to point the camera

upwards which avoids converging verticals. A grid focusing screen fitted to the camera makes this operation more accurate and easier.

By using the sideways movement, obtrusive objects can be pushed out of the picture without moving the camera. You could also take two pictures one after the other moving the lens first to the left and then to the right to achieve a stereo effect.

By moving the TS 35mm,f/2.8 you gain the opportunity normally only available to large format cameras. You can extend

The TS 35mm,f/2.8 - without FD characteristics - can be moved laterally about its axis. This enables converging verticals, for example, to be avoided. The extent of the depth of field can also be increased without stopping down.

the depth of field without stopping down the aperture, provided that subject plane, main plane of the lens, and film plane on their extensions, intersect. This is called the "Scheimpflug condition".

A frame to the subject, such as this creeper, is often important from several points of view. For one, it gives an enclosed impression to the picture. It also guides the viewer to the actual subject - in this case the figures, and it provides depth.

Which lens when? - Converters

Truly speaking converters are not lenses that can be used to take a photograph on their own. The extender is attached between lens and camera, it increases the focal length but reduces the speed of the lens. A 2x extender doubles the focal length while reducing the light intensity by two stops. A 1.4x extender increases the focal length 1.4-times reducing the light by one aperture stop.

Canon extenders are specially designed for certain. Extender FD 2x A and Extender FD 1.4x A apply to lenses from 300mm onwards and Extender FD 2x B is designed for focal lengths of 200mm.

Which lens when? - Other makes

Although the Canon lens system, despite several deletions, is still quite extensive some of the lenses have become rather expensive. This is where the ranges of other manufacturers can be used very well with Canon SLR cameras. To mention but a few there are three zooms from the well-known Vivitar Series 1. The 24-70mm,f/3.8-4.8 is a small, compact wide-angle/normal zoom lens (some might call it a wide-angle tele zoom), which together with the 70-210mm,f/2.8-4 would make a good combination. Another addition could be the super telephoto 100-500mm,f/5.6-8 which despite its extensive range of focal lengths is quite slim and light enough to be hand-held. It can also be set on a small tripod to avoid the camera shake usually expected with a focal length of 500mm. Recommended high-speed films for this lens are Ektachrome 400 or even Ektar 1000.

The colours of sunlit autumn foliage can be emphasized by a shorter exposure - between 1/3 and 1 aperture stop.

Exposures from close up can either be made with zooms on a macro setting or with special macro lenses. Both methods have one thing in common - a very small depth of field.

Some fixed focal length lenses from the Sigma range also complement the Canon system quite well. The 15mm,f/2.8 fish-eye, for example, or the 90mm,f/2.8 Macro or 400mm, f/5.6 telephoto which is also available in the slightly dearer APO version. An aperture of f/5.6 is a good choice for these lenses, and when an ISO 200 or 400 film is loaded even hand-held exposures are possible. A tripod is always preferable, though, as it would be a pity to destroy the high performance of the lens through camera shake. This applies in particular to the 600mm, f/8 mirror lens. Not only are mirror lenses light and comparatively compact they also feature a circular front lens allowing blurred picture parts to be emphasized by blurred rings which is particularly effective on reflective surfaces (water, paint).

Terminology - A few explanations regarding the lenses

An "L" in the name of an FD lens indicates that these lenses have been constructed with specially shaped elements (aspherical) or from special materials (fluorite, UD glass). Very fast lenses, lenses with very long focal lengths, and zooms with an extreme focal length range, are thus improved for a better imaging performance. (When chromium plated rings were used the designation was "AL".)

Lens speed...
...indicates how wide the aperture of the lens can be opened. Like all aperture values it is given as the ratio of the entrance pupil to the focal length. This gives a way of expressing and comparing lens aperture which is independent of focal length. With f/8 the entrance pupil divides into the focal length eight times and there is always the same amount of light reaching the film at the same f/number.

The lens speed is determined by the largest aperture. The lower the number the higher the speed, but a slower lens is not necessarily inferior to a fast one.

A large maximum aperture offers advantages which must be utilized to warrant the higher price of these lenses.

First advantage: The faster lens gives a brighter viewfinder image making focusing quicker and more accurate. This is a serious argument for fast lenses - but up to f/4 all FD lenses can be focused well on Canon F and A series cameras, and there are almost no problems on the bright screen of the AE-1 Program even when apertures of f/5.6 and slower are used.

Second advantage: Fast lenses can be used hand-held and without flash where a slower lens would require a tripod or flash. This advantage, however, must be paid for by a high price, a great weight and a very small depth of field with wide open aperture. The high price must be paid and the heavy weight must be carried even when the lens is used stopped down. If you can normally do without the wide open aperture you should really consider whether or not to buy such an expensive lens. A slightly slower lens used with a good tripod might be the better investment.

Third advantage: Fast lenses possess a high prestige value and there are many available in the Canon system.

The extent of the depth of field can be determined by using the depth of field scale between the focusing ring and aperture ring.

The macro setting...

...found on many zooms is an option which cannot really replace a true macro lens for the dedicated macro photographer. But an image ratio of 1:4 is sufficient to capture a butterfly or an exotic bloom. By stopping down the lens - to f/8 or f/11 - good results can be expected. A tripod could prevent camera shake in this situation.

The perspective...

...actually has nothing to do with the lens. It depends on the shooting position, e.g. if you are close to or far away from the subject. A change in the lens does not alter the perspective. But a single step forward or backward will.

Despite this, the focal length does have some bearing on the perspective, using a wide-angle you approach the subject more closely, with a telephoto you stay away further.

When shot with a telephoto objects which are separated from one another appear more closely together, and when shot with a wide-angle they appear further apart. These effects are known as "flat tele perspective" and "steep wide-angle perspective".

Light giants, such as the FD 85mm, f/1.2 L, are rather expensive so it must be decided if the high power is really needed.

Depth of field...

...also depends on the lens. The faster the lens the smaller the depth of field. But the depth of field is also governed by the shooting distance and the aperture selected. The greater the shooting distance the greater the depth of field and the depth of field is greater with small apertures than with large ones. The individual factors add up - a stopped down wide-angle lens over a great distance offers large depth of field which could extend from a few metres to infinity. But the individual factors can also cancel each other out; a telephoto lens could have the same depth of field as a wide-angle when it is used, for example, from a greater distance with a smaller aperture.

The depth of field scale...

...is simple to use. To the left and right of the index mark the aperture scales are indicated mirror fashion. The large apertures are closer to the index, the smaller apertures are further away from it. When the distance is set on the index, two equal aperture values indicate the extent of the depth of field with that particular aperture and focusing distance.

The snapshot setting...

...utilizes the large depth of field with fast lenses and small apertures. These two settings determine a particular depth of field for a particular f/number which can be read off the depth of field scale of the lens. When you photograph a subject inside the depth of field there is little need to focus and you are just as quick, if not quicker than someone using an AF camera.

It is important that the lens features a depth of field scale which is the case with most fixed focal lengths. This scale is frequently missing from two-touch zooms as it would make these too complicated, whereas with sliding zooms this scale is often in the form of a fan.

Converging lines...

...are a perspective effect. Parallel lines leading away from the viewer converge together. Such lines often are the corners of houses and when the camera is pointed upwards to include the entire house in the picture they extend away from the camera, i.e. in the picture they converge together. As the viewfinder of an SLR camera reflects the image that will be seen on the picture afterwards, these converging lines can be taken into consideration before the shot is made. You could move further away from the building or you could go closer to it to emphasize these lines as a feature.

Leaning verticals are usually objectionable, but they can be used to good effect. The steeply converging vertical lines resulting from photographing a tall building from close to will emphasize its height.

The flash - Light into the Dark

"At last it is possible to do what you always wanted - take photographs. And this applies to interiors as well as to night-time. Just slide the Speedlite 155A into the hot shoe, switch on, and as soon as the flash-ready light comes on, the AE-1 automatically switches to $^1/60$ sec, sets the program aperture, and adjusts the flash light to your focused distance. True automatic flash in a compact ESR - another pioneering effort from Canon" (From a Canon brochure 1977)

Today there are indeed cameras available featuring automatic flash - the Canon EOS series, for example. The light reflected from the subject is metered by the camera, and the flash is switched off by the camera when the main subject has been exposed correctly, at the same time the exposure of the background is adjusted to the main subject.

When the Canon F-1 appeared on the market this kind of flash photography was unheard of - although the CAT system of flash control already provided a great help for the photographer - and even the automatic flash of the AE-1 cannot compete with the newest flash technology.

Whether using an F-1, AE-1 or even the AE-1 Program - there will always be situations where a flash unit is necessary, for example, when there is not enough light without flash or when flash is used as fill-in to compensate for high contrast.

System units - loyalty is honoured

The arrival of the Canon AE-1 marked the triumph of system flash units. Before that any flash unit could be used with any camera via a hot shoe or sync cable. Automatic conversion to the sync speed and automatic aperture selection put an end to

Technical detail can often only be captured by using a flash. With computer control exposure is simple.

free choice - at least for those wishing to make use of the features offered.

The automatic guide number...
...or CAT (Canon Automatic Tuning) system brought us dedicated flash units designed to be used with the Canon FTb, F-1 and EF cameras with specific lenses.

The Speedlite 133D was designed to be used with the FTb and EF and the Speedlite 500A with the F-1. The later flash unit disappeared from the price list quite quickly, however.

Via a coupling ring the lens reads off the distance, automatically adjusts to the guide number, and the correct aperture is selected.

You set the correct aperture value on the F-1 and FTb by following the indication in the viewfinder. The EF automatically sets the aperture. This process can be compared to that of TTL flash control - you only need to set the sync speed and focus. There is no flash exposure metering, however, and there

is only one aperture available for each distance - the one resulting from the guide number formula.

Automatic flash...

...in cameras of the A series and the Speedlites of the A series is based on the camera switching over to the sync speed when the flash is charged and the fact that the flash aperture preselected on the flash is automatically transferred to the lens. In this way two important error sources for wrongly exposed flash photographs have been eliminated: selection of a sync speed too fast and setting errors when selecting the flash aperture.

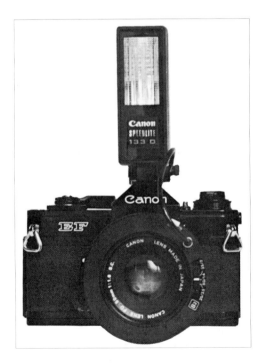

CAT system flash: The distance selected is read by the coupling ring within the filter thread of the lens. A suitable flash aperture is automatically calculated and in the case of the Canon EF also set from this value together with the guide number of the flash. The aperture must be set manually with the F-1 and FTb cameras where the index in the viewfinder is a useful setting aid.

The Canon Speedlite of the A and G series are computer flash units which control the flash exposure according to the film speed. The Speedlite system ranges from the small pocket flash to the giant flashgun - a flash for everyone.

The Speedlite 133A was introduced together with the Canon AV-1 and can, of course, be used with any other camera of the A series featuring automatic setting of sync speed and computer aperture. Its metre guide number is 16 for ISO 100/21° and it offers one computer aperture.

The Speedlite 155A introduced with the Canon AE-1 has a guide number of 17 with ISO 100/21° and features two computer apertures (f/2.8 and f/5.6 with ISO 100 film). The flash reflector is fixed. The unit is small and compact and should always be carried so that any shadows can be lightened when required.

Speedlite 166A accompanied the Canon AL-1 QF, regarded by many as a forerunner of modern autofocus SLR cameras. This flash features a guide number of 20 and two computer apertures.

Speedlite 177A with a guide number of 25 approaches the Speedlite 199A in performance. But compared to the top model its features are simplified - it has a fixed reflector and only two computer apertures (f/2.8 and f/ 5.6 for ISO/21).

Speedlite 188A, presented together with the AE-1 Program, has a guide number of 25 and two computer apertures but it also features a flash-ready display in the viewfinder.

The powerful Speedlite 199A with a guide number of 30 came on the market together with the Canon A-1. Again the computer apertures are f/2.8 and f/5.6, but in addition there is a third aperture of f/11. Maximum flash distance in computer mode is 10 metres. The indicator can be illuminated by pressing a button. A test release provides the option of operating the flash manually. The green flash-ready display in the viewfinder indicates that the flash is sufficient for the main subject.

An important characteristic of the Speedlite 199A is the adjustable reflector making it easy to use indirectly.

Together with the Canon F-1N the Speedlites of the G series came on the market but they can also be used with A series cameras. These flashes are very powerful units, the 533G has a guide number of 36 with ISO 100/21° and the 577G as high as 48. Both units feature movable and revolving reflectors, three computer apertures and an external sensor which can be inserted into the hot shoe of the camera. Automatic switch-over to the sync speed and the computer aperture preselected on the flash is possible with these units.

A very special flash unit is the Macrolite ML-1 whose ring-shaped flash head with two reflectors are screwed into the filter thread of the camera lens. The reason is that when shooting macro pictures the distance between front lens and subject is too small to be illuminated with an ordinary flash. When using one of the macro lenses of the Canon system to make a documentary of small objects, switch on both reflectors

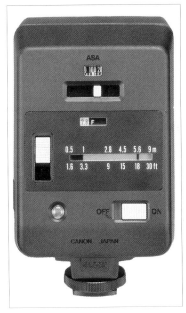

The Speedlite 188A was introduced together with the AE-1 Program. When the flash is ready, the sync speed and the computer-selected aperture on the flash (here 2.8) are set automatically. This also applies to the A-1 and the AE-1. But the LED panel in the viewfinder of the AE-1 Program also informs you when correct exposure has occurred.

for the subject to be illuminated without shadows. If a fine-grained film such as Kodachrome 25 or Ektachrome 50 HC is used every detail will be visible as a result.

When photographing flowers such an illumination might be inappropriate - especially when the pictures are not to be used for scientific purposes. Shadows play an important role in the composition of pictures, as they add depth. The reflectors of the Macrolite ML-1 can therefore also be used independently and can be turned so that the light comes from an angle.

As far as exposure control is concerned the Macrolite ML-1 is a computer flash whose sensor is positioned in the flash head and thus can receive the light reflected by the subject.

The control unit is inserted into the hot shoe of the camera, the power unit - connected to the control unit by a cable - can be placed at the side of the camera.

Canon continued the development and production of flash units with the Speedlite 430EZ and 300EZ geared for A-TTL controlled units such as the EOS series. But T and E series flash units were designed for their respective camera generations and when used in conjunction with older camera could lead to errors.

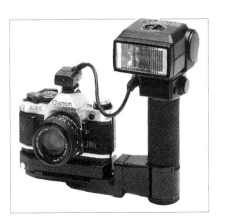

The sensor of hammerhead flash units of the Speedlite G series is attached to the hot shoe providing very precise exposure measurement. When used in conjunction with A-series cameras, automatic functions such as sync speed setting and flash aperture remain.

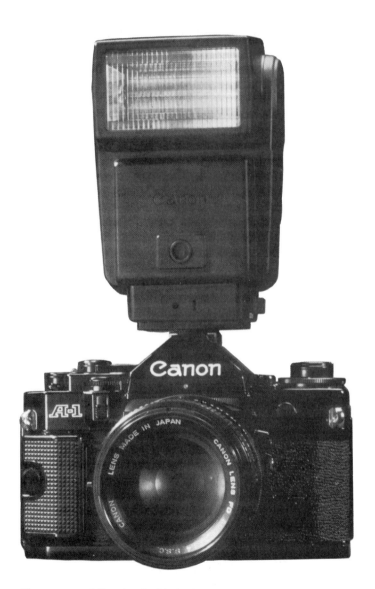

The most powerful hot shoe flash in the Speedlite A series is the 199A introduced together with the A-1. It offers three computer apertures - flash exposure is metered via a sensor in the front of the unit - and a movable reflector which is very important for picture composition with flash.

Terminology - a few explanations regarding flash units

The computer flash...

...is not actually a computer. Principally it resembles a simple calculator. The computer flash has a sensor catching the light reflected from the subject and measuring it. The computer switches the flash off when there is sufficient light to expose the film - that could be after $^1/5000$ sec or after $^1/1000$ sec.

This calculation occurs inside the flash unit. To achieve correct exposure of the film the lens aperture must be set to the value metered by the flash. Simple units offer one such computer aperture, more sophisticated units feature several apertures. The process usually consists of partial covering of the sensor. Now the aperture selected on the flash can be transferred to the lens manually, which could lead to errors, or automatically, which is safer and easier. Computer apertures

A young rabbit photographed against a white background with two flash units.

depend on the film speed. When the film speed is altered on the dial of the flash a corresponding computer aperture will be indicated.

There are also removable sensors which enable you to use this type of exposure control even with indirect and separate flash units.

Indirect flash...

...can soften harsh flash light. The light reaching the subject from a reflective surface casts softer shadows and the light seems more natural. Flash units with movable reflectors are most suitable for indirect flash. When using colour slide film it is important that the reflecting surface is white as the film colours might be changed by the reflection. If there is only a dark ceiling, however, or it is too high, a clip-on reflector could come in useful.

The separate flash...

...is required when you want to illuminate the subject from the side or when the flash light should resemble the morning sun. The flash unit must be separated from the camera and connected to the flash socket by a long sync cable. The guide number calculation must be adjusted to the actual flash-subject camera distance which might be too much for the computer control unless you use an external sensor such as offered by the Canon G series Speedlites or the Vivitar 283.

The guide number...

...indicates the efficiency of the flash unit. It corresponds to a certain film speed, ISO 100/21°, and a certain distance in metres. The relationship between guide number, flash aperture and distance is reflected in the guide number formula:

flash aperture = guide number/distance

To find out how far you can use a flash of a certain guide number with a certain aperture simply reverse the formula:

distance = guide number/aperture

Both formulae should be used carefully as a certain amount of light is lost in large dark rooms or outside at night time. It is

advisable to open the aperture by one stop or to use more than the calculated maximum range.

The sync speed...
...is the shutter speed at which the first blind has uncovered the film opening while the second blind has not yet started to cover it again. A brief flash will fall onto the entire film area. If the sync speed is too fast the second blind has already started by the time the flash occurs and darkens part of the film. The result of this can be seen as a black strip.

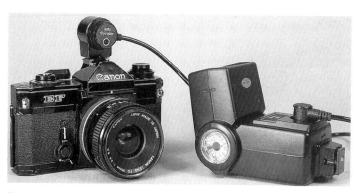

The Vivitar 283 - another old-timer on the market since the 70's and still finding a lot of buyers - features a detachable sensor. It can be attached to the camera's hot shoe for indirect flash. There is a choice of four computer apertures.

Other brand flash for the F series - Vivitar 283, the light machine

The range of Canon flash units for the A series is wide and there should be no problem finding a suitable model for your requirements. If you want to use one of the older F series cameras with a flash it might be worth looking at what other flash manufacturers can offer. As useful as the CAT system is, output of the Speedlite 133D is not very high and, even more annoying, most lenses cannot be used with it.

Vivitar offer a compact clip-on unit, Vivitar 283 with a guide number of 36, equipped with a movable reflector and it can be set to four computer apertures.

The light sensor is built into the unit but can be removed and connected to the flash by a cable. This way the sensor can be attached to the hot shoe of a Canon EF or FTb while the flash is held in the hand. However, the wide range of accessories features a well-designed hand grip which can be fitted with a cable release and the combination of flash, hand grip and camera can be held quite comfortably this way. The hand grip can be fitted to the other side of the camera for left-handed users.

The unit's dial can be illuminated. Another good feature is the flash charging indicator. A light will show when the unit is ready but the condenser not yet fully charged. An audible signal indicates when the condenser is full. Charging of the condenser is quite quick due to the thyristor storing any unused energy for the next flash.

Correct exposure is indicated by an flash-ready signal on the unit.

The accessory range mentioned also includes diffusing screens for wide-angle shots, tele adapters concentrating the light, colour filters and battery adapters which can be fitted with four 1.5V cells.

Films - No Picture without Them

Cameras, lenses and flash units build the foundation of any photographic equipment. But without a film they are lifeless.

The range of films available was never as attractive as now and talk of electronic photography seems to be a theoretical phenomenon yet. Electronic stills recording doubtlessly is advancing - but there is still nothing better yet than the good old silver film.

Black-and-white films - better than ever

Black-and-white films are gaining in favour although they still have some way to go before reaching the level of popularity of the 50's and 60's.

The quality of modern black-and-white films such as the Kodak T-Max series seems unsurpassed although certain improvements are still to be expected. Fine grain and resolution enable us to record even the minutest structures sharply. The ISO 100 films especially show hardly any grain even when greatly enlarged and the higher speed films such as T-Max 400 or T-Max P3200 (which can be exposed at ISO 400/27° or ISO 6400/39°) give excellent results nobody would have believed possible a few years ago.

Indeed, new emulsion technologies have made ISO 400 black-and-white films so good that many photographers use them all the time and only resort to ISO 100 films for the macro photography of detailed subjects.

It still recommended to expose generously and develop for a little shorter time in order to achieve pictures with well graded shadows and highlights - just like the photographers of yesteryear when they produced their now-famous black-and-white pictures with rangefinder Leicas. When metering the

exposure, direct the camera towards the darker parts of the subject and store the respective values. You will find out how to develop these films to achieve high quality negatives by experimentation.

Colour negative films - Versatility or something special?

Colour negative films are the most popular films but they are not all the same.

Choose a film such as Kodacolor Gold when you want normal prints of the whole negative which you can then store in a photo album or hang on the wall, and also when you know that your film will remain in the camera for some time. These films are good-natured products where the exposure range is concerned.

With SLR cameras with TTL metering the exposure range of the film is not as important as with compact cameras. But even with an SLR such as the Canon FTb or AE-1 it might be comforting to know that over- or underexposure within two aperture stops will not lead to ruined pictures.

As these films can be regarded as general purpose films, suitable for simple compact cameras as well as sophisticated SLRs the film speeds are graded to accommodate all camera types.

An ISO 100 film such as Kodacolor Gold 100 is suitable for any situation - from close-ups to portraiture and architecture to landscape photography.

An ISO 200 film (e.g. Kodacolor 200) is especially suitable for landscapes, snapshots and indoor portraits and can be regarded as universal material when slow zooms such as the notable old FD 80-200mm,f/4 are used.

In the same situation an ISO 400 film would bring a shutter speed faster by one step. It should not be considered as a film for all situations, however. This film performs best when shooting without a tripod in low light, outside, at dusk, as well as indoors, or with flash when maximum reach is needed.

A zoom enables you to take either an overall view or a detail shot from the same position. Keep an eye on the shutter speed as there might be danger of camera shake. Choose an ASA 200 or even 400 film if you think you may have a problem here.

For very big enlargements, sectional enlargements or fine structures, high performance films such as those from the Kodak Ektar series are the right choice. They offer a lot but they also demand a lot of the photographer.

The very low speed Ektar 25 is recommended where high resolution, extreme sharpness and fine grain are important, e.g. macro photography or finely structured subjects. The negatives can be enlarged to quite a large format without any visible grain.

The ISO 125/22° setting also presents no problems for Canon cameras and using Ektar 125, a top of the range film, is easy. Although not as fine-grained as the Ektar 25 it is much more sensitive to light.

The Ektar 1000 with a speed of ISO 1000/31° is designed for low light conditions. Even in border situations it is still fine-grained, it records shadow details well and in mixed light conditions such as daylight plus artificial light the reproduction of colour is still very satisfactory.

To make use of all the advantages of films like these, perhaps too good to be used for average pictures, the photographer needs to work a little harder. Even good lenses need to be stopped down by one or two stops to achieve the highest quality, exposure must be metered very accurately - which is especially easy with the Canon FTb and F-1 - and, if possible, the camera should be supported on a tripod to avoid camera shake.

Colour transparency films - the glowing picture

Although developing colour transparency films at home is possible it is not recommended. It is better to use a professional laboratory which can process the film very quickly.

The special design of Kodachrome films requires these to be processed only in Kodak laboratories. Principally these films are black-and-white films and during the exposure the colour information is stored in several layers which are sensitive to the three basic colours. Only when the film is developed are

the true colours processed into the layers. This is also the reason that Kodachrome films are comparatively thin and fine-grained making films of speeds ISO $25/25^0$, ISO $64/19^0$ and ISO $200/24^0$ exceptionally sharp.

Other colour transparency films such as Ektachrome are processed by the E-6 method. They are available with film speeds of ISO $50/18^0$, ISO $100/21^0$, ISO $200/24^0$ and ISO $400/27^0$, the 50 and 100 as HC versions characterized by especially rich, strong colours.

The top end of the Kodak range of films is marked by professional Ektachrome P800/1600 featuring variable speed. Of course, the entire film must be exposed at one speed.

Whereas Ektachrome P800/1600 and T-Max P3200 are only available in professional versions, the professional version of other films is merely a parallel to the amateur film.

Professional films are no better than the others - they are just more suitable for professional requirements. There will be no variation between films of the same batch, which could be important for long exposure series of the same subject under the same lighting conditions, for example, in a studio. Although variations are also unlikely in amateur films they are not guaranteed against them.

Professional colour films are at their best when they leave the manufacturer and to keep them that way they should be kept in the fridge until they are used. Adequate warm-up time must be allowed to bring them up to room temperature otherwise condensation on a cold emulsion may give rise to image faults. Ideally, storage should be in a fridge, which is how distributors and professional dealers keep them. Exposed films should be processed as soon as possible after exposure.

Colour films intended for amateur use reach their best after a period of storage in a dealer's shop. If such films are bought in some bulk they should be treated in the same was as professional films and kept in the fridge until required.

Specialist films - always prepared

Specialist films are rarely used but can be found among the range offered by major film manufacturers like Kodak.

They include artificial light colour films which in my opinion should be much more widely used. Kodak Ektachrome 50T and Ektachrome 160T (T is for tungsten) are sensitized in such a way that the colours are correctly reproduced when the subject is illuminated by photographic lights, where daylight films would react with a yellow cast. On the other hand artificial films exposed to daylight show a distinctive blue cast.

Other specialist films are infrared and duplicating films. Films like Vericolor 400 (for studio portraits) or Ektapress 400 and 1600 are also films not used for normal photography.

Danger lurks when you take a picture over water such as the sea or a lake. The slightest movement of the camera will show up in the picture as a sloping horizon.

Accessories - Be Prepared for Any Situation

Original Canon accessories covered many catalogue pages and will still be available on the second-hand market. There are also products worth considering from other manufacturers. Some accessories for use with there cameras are introduced here.

Bellows - for close-up shots

Apart from special macro lenses, automatic bellows are the easiest route to macro photography, although they cannot be hand-held, unlike a camera with a macro lens attached. Appropriate bellows are connected directly to the cameras of the Canon A series and accept Canon FD lenses, or other optical systems which need to be focused with the bellows. The FD characteristics of the lens are retained irrespective of the extension of the automatic bellow unit, i.e. open aperture metering is possible and the automatic aperture functions without the need for a double cable release.

With the exception of macro lenses, all normal photographic lenses are computed to give their optimum performance when focused at infinity, i.e. small image ratios. When used in the close-up range they are still acceptable but you cannot expect such a high performance as is obtainable with specially computed close-up lenses.

When shooting macro subjects such as flowers, a tripod is necessary to support the bellows unit together with a macro setting slide which can be bought either matching the tripod or the bellows. The large image size would magnify any camera shake and without a slide exact focusing can be quite tricky. Focusing is not done with the lens but by moving the entire

camera backwards or forwards and this can easily be achieved by moving the slide.

A tripod with setting slide on which the camera with its macro lens can be slid backwards and forwards to focus precisely, helps when shooting from a very close distance.

Filters

It is not always necessary to protect the lens with a UV filter or skylight filter, but protection of the front surface in adverse weather conditions like pouring rain, on the beach, or during a snow storm is quite important and a filter can serve this purpose very well. When there is a high proportion of UV in the light then a UV or skylight filter is indispensable for good photography - for example, on the beach, or in high mountains they improve the picture by cutting out excessive blue. Unless these conditions are prevalent there is no reason to have a filter attached to the lens. The addition of the filter could actually alter the performance of your lens unless it was of high optical quality.

When going on holiday the amateur photographer usually carries more than just a camera and a lens. A good camera bag contains everything conveniently to hand when faced with an interesting subject.

Polarizing filters can remove the glare from non-metallic reflecting surfaces, increase the transparency of glass and water and reproduce colours more brilliantly.

Colour filters enhance the colour differences in the subject in black and white pictures. A well-known example is a deep yellow filter that makes the blue of the sky appear darker and emphasises the clouds. Graduated grey filters can help to improve the picture by controlling contrast. The dark portion reduces the bright light from the sky.

Your photographic equipment should include these filters for every lens - this can become quite expensive as FD lenses do not all have the same diameter. Some duplication can be solved by using reducer rings, but it is preferable to use system filters such as those available from Cokin. A central part of the Cokin system is an adapter by which the filters can be attached to lenses of various diameters. Adapter A is suitable for the Canon FD lenses with diameters between 36mm and 62mm. When using larger lenses Adapter P is needed.

Examples of creative filters are diffusing filters, diffraction and prism filters, graduated, starburst and dream filters, all of which add special effects to your photography.

Another reason for choosing the Cokin filter system is the filter holder which can accept a square lenshood - a single one for shorter focal lengths or large aperture lenses, or several combined to protect a telephoto from stray light.

A lens hood is important for good pictures by keeping out stray light which causes flare and reduces the contrast in the image.

A heavy tripod is important but not walways available. A small tripod such as the Cullmann Magic II helps to prevent camera shake and can easily be carried around in your accessory bag.

Tripods - avoid camera shake

When a picture is enlarged sufficiently it may be noticed that even a shutter speed of $^1/125$ sec was not enough to steady a 85mm lens. But generally the rule of thumb applies:

slowest shutter speed for hand-held exposures equals one divided by the focal length in mm.

When the shutter speed approaches that value the camera needs to be supported on a tripod. If you do not want to carry a full size tripod, then tabletop tripods can be obtained which fold up small enough to be carried in a pocket or camera bag, but are still rigid enough to support the camera firmly. However, for tripod exposures with the Canon A-1 plus Motor MA with long telephoto you will need a strong and heavy tripod. The correct head for the tripod is just as important as the tripod itself. A pan and tilt head offers great flexibility as it can be adjusted to any direction. A small spirit level attached to the hot shoe helps in levelling the camera accurately.

The cameras in detail

	FTb	F1	EF	AE-1	A-1	AE-1Program
Shutter						
- electronically controlled			x	x	x	x
- mechanically controlled	x	x	x			
- slowest speed (sec)	1	1	30	2	30	2
- fastest speed (sec)	1/1000	1/2000	1/1000	1/1000	1/1000	1/1000
- sync speed (sec)	1/60	1/60	1/125	1/60	1/60	1/60
Viewfinder						
- fixed	x		x	x	x	x
- interchangeable		5				
- interchangeable focusing screens		9			7	8
Viewfinder information						
- shutter speed	(x)	x	x		x	
- aperture			x	x	x	x
- overexposure	x	x	x	x	x	x
- underexposure	x	x	x	x	x	x
- flash ready				x	x	x
- flash OK						x
Exposure metering						
- selective	x	x				
- integral			x	x	x	x
- memory					x	x
- CdS cell	x	x				
- Si cell			x	x	x	x
Exposure control						
- aperture priority	x	x	x	x	x	x
- shutter speed priority		(x)	x	x	x	x

	FTb	F1	EF	AE-1	A-1	AE-1Program
Exposure control						
- programmed exposure					x	x
- compensation factors					+/-2	
Film speeds (ASA values)						
- lowest	25	25	12	25	6	12
- highest	(1600)	3200	3200	3200	12800	3200
Automatic flash						
- CAT	x	x	x			
- automatic setting of computer aperture				x	x	x
- automatic setting of sync speed				x	x	x
Features						
- self timer	x	x	x	x	x	x
- multiple exposure button		x	x		x	
- stop-down lever	x	x	x	x	x	x
- winder attachable		x		x	x	x
- motor drive attachable		x			x	x
Dimensions						
- width (mm)	144	146,7	151	141	141	141
- height (mm)	93	99,5	96	87	91,5	88
- depth (mm)	43	49,5	48	47,5	47,5	47,5
- weight (g)	740	845	740	590	650	575

Details of FD lenses available before the introduction of the EOS series cameras

Maximum aperture and Focal Length	Type	Closest Focusing Distance	Filter Diameter	Length	Weight
5,6/7,5 FE	SSC	fix	B/I	62	380
5,6/7,5 FE	new	fix	B/I	62	380
2,8/14 L	new	0,25	S	83,5	490
2,8/15	SSC	0,3	B/I	60,5	500
2,8/15	new	0,2	B/I	60,5	470
4/17	SSC	0,25	72	56	490
4/17	new	0,25	72	56	375
2,8/20	SSC	0,25	72	58	400
2,8/20	new	0,25	72	58	320
2,8/24	SSC	0,3	55	52,5	410
2,8/24	new	0,3	52	43	280
2/24	new	0,3	52	50,6	310
1,4/24 AL	SSC	0,3	72	68	500
1,4/24 L	new	0,3	72	68	430
3,5/28	SC	0,4	55	43	290
2,8/28	SC	0,3	55	49	280
2,8/28	new	0,3	52	40	210
2/28	SSC	0,3	55	61	343
2/28	new	0,3	52	47,2	280
3,5/35	SC	0,4	55	49	325
2,8/35 TS	SSC	0,3	58	74,5	545
2,8/35	new	0,35	52	40	200
2/35	SSC	0,3	55	60	420
2/35	new	0,3	52	46	260

3,5/50 Macro	SSC	0,24	55	59	310
3,5/50 Macro	new	0,23	52	57	240
1,8/50	SC	0,6	55	44,5	305
1,8/50	new	0,6	52	35	180
1,4/50	SSC	0,45	55	49	370
1,4/50	new	0,45	52	41	240
1,2/55	SSC	0,6	58	52,5	565
1,2/50		0,6	58	52,5	510
1,2/50	new	0,5	52	45,6	315
1,2/50 L	new	0,5	52	50,3	380
1,2/55 AL	SSC	0,6	58	55	605
1,2/55 Asphère		0,6	58	55	575
2,8/85 SF	new	0,8	58	69,6	400
1,8/85	SSC	0,9	55	56	445
1,8/85	new	0,85	52	53,5	350
1,2/85 AL	SSC	1,0	72	71	750
1,2/85 L	new	0,9	72	71	680
4/100 Macro	SC	0,4	55	112	540
4/100 Macro	new	0,45	52	95	480
2,8/100	SSC	1,0	55	57	430
2,8/100	new	1,0	52	53,4	300
2/100	new	1,0	52	70	450
3,5/135	SC	1,5	55	83	480
3,5/135	new	1,3	52	85	360
2,8/135	new	1,3	52	78	420
2,5/135	SC	1,5	58	91	670
2/135	new	1,3	72	90,4	700
4/200	SSC	2,5	55	133	725
4/200	new	1,5	52	121,5	500
4/200 Macro	new	0,58	58	182,4	830
2,8/200	SSC	1,8	72	140,5	700
2,8/200	new	1,8	72	140,5	700
2,8/200	new 2	1,5	72	134,2	735
5,6/300	SC	4,0	58	173	1225

5,6/300	SSC	3,0	55	198,3	685
5,6/300	new	3,0	58	198,5	685
4/300 L		3,0	S	204	1100
4/300 L	new	3,0	S	207	1100
4/300	new	3,0	S	204	945
2,8/300	SSC	3,5	S	230	2000
2,8/300 L	new	3,0	S	208	1100
4,5/400	SSC	4,0	S	282	1400
4,5/400		4,0	S	282	1300
2,8/400 L	new	4,0	S	348	4500
4,5/500 L		4,0	S	383	2600
4,5/500 L	new	4,0	S	395	2900
8/500 Reflex	SSC	4,0	S	146	740
8/500 Reflex	new	4,0	S	146	705
4,5/600	SSC	8,0	S	455	4300
4,5/600	new	8,0	S	462	3740
5,6/800	SSC	14,0	S	567	4300
5,6/800 L	new	14,0	S	577	4400
3,5/20-35 L	new	0,5	72	84,2	470
3,5/24-35 AL	SSC	0,4	72	86,3	515
3,5/24-35 L	new	0,4	72	86,6	500
3,5/28-50	SSC	1,0	58	105	470
3,5/28-50	new	1,0	58	99,5	455
3,5-4,5/28-55	new	0,4	52	60,9	220
4/28-85	new	0,9	72	104,1	485
4/35-70	new	0,5	52	85,5	315
4/35-70 AF	new	1,0	52	84,5	640
3,5-4,5/35-70	new	0,5	52	63	200
2,8-3,5/35-70	SSC	1,0	58	114,5	600

2,8-3,5/35-70	new	1,0	58	120	560
3,5/35-105	new	1,5	72	108,4	640
3,5/50-135	new	1,5	58	125,4	720
4,5/50-300 L	new	2,5	S	250	1945
4,5/70-150	new	1,5	52	132	565
4/70-210	new	1,2	58	151	705
4,5/75-200	new	1,8	52	123	510
4/80-200	SSC	1,0	55	161	750
4/80-200	new	1,0	58	161	790
4/80-200 L	new	1,2	58	153	675
4,5/85-300	SSC	2,5	82	247,5	1940
4,5/85-300		2,5	S	243,5	1695
5,6/100-200	SC	2,5	55	173	820
5,6/100-200	new	2,5	52	167	660
5,6/100-300	new	2,0	58	207	835
5,6/100-300	new 2	2,0	58	172	705
5,6/100-300 L	new	2,0	58	172	710
5,6/150-600 L	new	3,0	S	468	4350

Explanations

"AF" signifies a lens equipped with autofocus features - for automatic range-finding and setting of Canon cameras with FD connections.

"AL" and "L" signifies lenses with elements made from special materials or with aspherical surfaces.

"FE" means fisheye lens with an image angle of 180° in all directions. It has no FD connection.

"SF" signifies a lens which can be used for soft focusing.

"TS" signifies a lens which can be moved out of and against its optical axis. It has no FD connection.

"SC" and "SSC" signifies the type of lens coating. They all have chromium rings.

"New" lenses are those introduced to the market without chromium rings.
Lenses without designation in the type column appeared in the transitional period between chromium ring lenses and FD lenses of the second generation.
B/I signifies filters built into the lens.
S signifies that special filters are needed, usually behind-the-lens filters or filters that are placed in a filter slot.

ACCESSORIES WELL WORTH LOOKING AT!

OP/TECH

The world's most comfortable cameras, bag and tripod straps (binoculars too). Op tech has a built-in weight reduction system that makes equipment feel 50% lighter and 100% more comfortable. From the famous 'Pro-Camera Strap' to the 'Bag Strap' and the 'Tripod Strap', the style, colours and comfort which along with the non-slip grip, ensure that you have a wonderful combination of comfort and safety.

RUFF-PACK®MODEL 710
Classic SLR Bag

Our most compact SLR bag, the Model 710 out-performs many larger bags. A 35mm SLR camera with zoom lens fits snugly into the center of the bag while two additional lenses, or a lens and a flash, may be carried in the compartments on each side of the camera. Two large front pockets give plenty of room for carrying film and accessories. Carrying options include a large handle on top and a detachable shoulder strap.

LUMIQUEST

For any portable flashgun that has a bounce head. Lumiquest is an accessory system that has a place in everybody's camera bag. Not just to reduce 'red-eye', but from the simple 'Pocket Bounce' through to the 'Softbox', added diffusion for flash portrait or close-up's of still life can be achieved while at the same time Metallic Inserts in silver will give spectacular highlights and in gold, a warm sunset tone. Snoots and Barndoors are part of the system for the creative flash photographer.

GOTCHA WRIST STRAP™

GOTCHA WRIST STRAP™ is a safe bet to a secure carrying system. It wraps snugly and comfortably around the wrist and attaches easily to a camera, binoculars, video camera or personal stereo player. The specially bonded neoprene is designed to work with the Velcro®-type fastener to form a secure, yet adjustable closure. This hook and loop fastener engages to provide a strong grip force ensuring a positive hold. The quick disconnect enables the user to quickly remove the strap to change film and batteries.

KINETICS/TUNDRA SEA KING

The tough hard-shell case (known as Tundra Sea King in the USA) that is favoured by all those who travel and have a need to fully protect valuable camera or electronic equipment. Made of hard industrial plastic that will withstand the rigours of travel, with the added advantage of being airtight, dust-tight and watertight when locked down. With a Kinetics case you can now enjoy taking your valuable equipment wherever you want in the knowledge that it will be safe from impact, dust and moisture.